The
Digital
PHOTOGRAPHY
Handbook

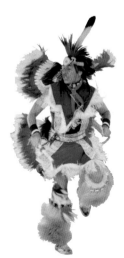

The

Digital

PHOTOGRAPHY

Handbook

Simon Joinson ▶

metro

First published in flexible hardback in Great Britain 1998 by Metro Books (an imprint of Metro Publishing Ltd), 19 Gerrard Street, London W1V 7LA.
This updated second edition published 1999.
Reprinted 2000

Conceived, edited, designed and produced by Duncan Petersen Publishing Ltd,
31 Ceylon Road, London W14 OPY.

Chief contributor, Simon Joinsen.

British Library Cataloguing in Publication Data. A CIP record of this book is available on request from the British Library.

ISBN 1 900512 91 2

10 9 8 7 6 5 4 3

Typeset by Duncan Petersen Publishing in QuarkXPress; reproduction and film output by Book Originations, Isleworth, TW7 6ER

Printed in Slovenia by Delo-Tiskarna

CONTENTS

DIGITAL OVERLOAD?

It seems as though the whole world is going digital. Your lovely black vinyl LP is ousted by little silver discs; mobile phones come the size of bus tickets; and now, having just spent a fortune on a new NICAM stereo TV, you find that *digital* TV means upgrading again or missing out. It's starting to look like an elaborate marketing scam to keep people salivating at the feeding trough of consumer electronics, but in practical terms, the constant stream of developments are not as disturbing as you might think. Digitization simply means the *integration* of electronic appliances, thus multiplying their power and usefulness.

0 and 1

What unites CD players, the Internet, mobile phones, e-mail, digital TV, word-processors and digital imaging is the simple ones and zeros of computer information: a universal language which can represent words, images, sounds and movement, with microprocessors as the common denominator. This leads to a marked improvement in clarity when it comes to sounds and images, as genuinely perfect copies can be made from any original. But, more important, these previously separate devices and activities can now be merged, extending the computer's endless ability for manipulation, storage, retrieval and transmission to all types of media. In other words, anyone can be a publisher if they own a computer – and have some commercial ideas.

SO WHAT ABOUT DIGITAL PHOTOGRAPHY?

Digital photography is about transferring traditional film and darkroom techniques to the desktop. But rather than just replacing smelly chemicals, the computer is offering new possibilities that are changing the whole way we approach taking pictures.

Editing and distributing images is clearly made easier if the same machine that you use to print documents and send e-mails also stores and manipulates photos. But this is only a start.

The *filmless* nature of digital photography is having a major impact. There is usually a moment before you press the shutter release in conventional photography when you have to make sure that everything is just right in order to avoid wasting an exposure. With a digital camera, you can take pictures forever, without having to think about wasted film. And, without even looking through the viewfinder, you have the potential to achieve results that you could never have anticipated with conventional film.

Not least, the arrival of digital imaging means a rekindling of your interest in, and the excitement you get from photography.

7

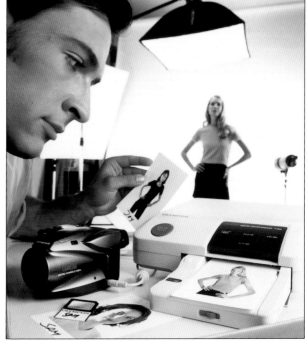

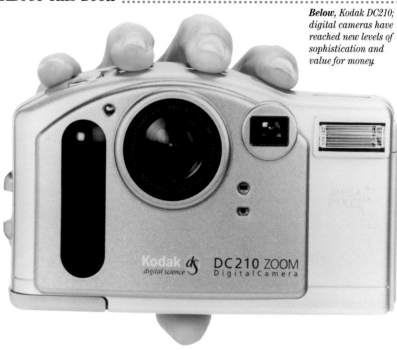

Below, Kodak DC210; digital cameras have reached new levels of sophistication and value for money.

8 Debates about the pros and cons of digital photography versus traditional photography often fail to distinguish between *where digital photography is today* and *what digital photography might mean in the future.* This book, by contrast, gets down to the business in hand: it looks at where digital photography is *now*: in its infancy, but developing at an amazing rate. We take this astonishing rate of development into account, without making the subject too complex. We have set out to demystify its technicalities, but without simplifying them to the point of absurdity. Above all, ***The Digital Photography Handbook*** is practical, full of real-life examples of basic operations.

Ultimately, you will have to experiment if you want to understand this subject, and we've written this guide with just that in mind. If you're worried about paying out the full price for software until you're sure digital imaging is for you, then just try one of the software packages on offer as a free trial. PhotoSuite, for example, is a good choice for beginners. Have fun...

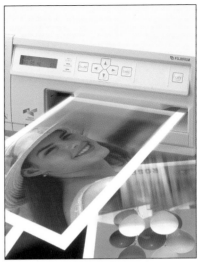

Above, a PC and digital imaging software provide the basis for experimenting with images. Right, results can be printed on a printer.

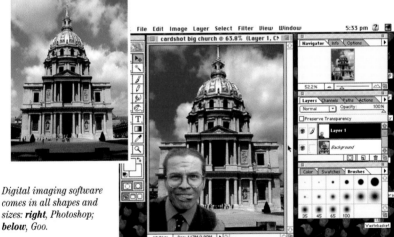

9

Digital imaging software comes in all shapes and sizes: right, Photoshop; below, Goo.

Illustrated here are only two of the ten or so digital imaging software packages currently available. Photoshop dominates, but it is worth looking at alternatives such as PhotoSuite, which is the ideal all-in-one package for non-intensive digital imaging.

WHAT IS DIGITAL PHOTOGRAPHY?

CCD
*Charged couple device
actual size 1 cm x 1 cm*

LCD screen
*A small colour
monitor allowing
previewing and
reviewing images
to check
composition.*

Digital cameras have lenses and shutters
which work in much the same way as
traditional ones. The big difference
between the two is the way images are
recorded and stored. Film, whether colour
or black and white, is replaced with an
electronic light sensor called a CCD or
charge-coupled device. Rather than the

Electronics

Lens

CCD

shutter exposing
photosensitive film, light is allowed to fall
on the CCD surface, where it is converted
to digital information and stored in the
camera's memory.

Pixels
The surface of the CCD contains a grid of
light-sensitive dots called *pixels.* These
record the amount of light falling on them
by storing it as a corresponding electric
charge. After the exposure, this grid can be
thought of as a draughtboard with a
different number of counters on each
square representing the charge level. The
number of counters on each square is read
off as a simple value. This collection of
numbers - and nothing else - is stored in
the memory (hence *digital*) and can later
be retrieved to make pictures.

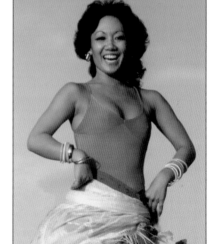

Digital photography in action / the colour factor

It is essential to understand that pixels can only describe the *light level*. Extracting this information alone would produce images in various tones of grey - 'grayscale'.

To make colour images, pixels are grouped together in clusters called *photosites,* and filters are used to make the individual pixels sensitive to a single colour. Because the human eye is most sensitive to green, each photosite is usually made up of four small square pixels, one red, one blue and two green. The output of one photosite therefore becomes one single pixel in the final image. So you should be aware that the quoted resolution of the CCD is not as great as it seems: a *bunch* of pixels on the CCD surface are needed to make *one* pixel in the stored image. The camera's processor then *interpolates* the information (makes an intelligent guess as to the colour of the 'missing' pixels) to produce the full resolution image. This system is called a *Matrix CCD.* The Matrix CCD system has many advantages; speed and cost being just two, but it can produce discernable colour fringing around edges (something which is exacerbated by high compression levels when storing the images).

Silicone substrate.

RGB filter matrix.

11

Why bother going digital?

Because digital images work seamlessly with other modern media such as the Internet and CD-ROMs, and because a computer gives such a wide range of possibilities for photo manipulation, storage and preparation, digital photography offers flexibility and excitement.

It comes into its own when speed is essential, especially if images need to be sent from one place to another, as in journalism, and other commercial situations. Most images in commercial use will be put through a computer at some stage and if they are already in the form of computer data, then this process is streamlined. Estate agents can take a digital camera to a property and produce a colour brochure the same day. The rapid growth of the Internet means that digital images can be shared with millions of people instantly, or using systems such as Fuji's PhotoNet, electronic post cards can be sent around the world.

But for amateur photographers, its main appeal is creative: clicking the shutter becomes just the start of the process of picture-making, given the almost endless scope for manipulation and composition available through computer software.

are designed to produce, and is the system often referred to as *true colour*. It gives a range of 16.7 million possible colours. How many colours an image contains is known as the *bit depth* (true colour is 24-bit and is the most current computer software can handle).

Left, 24-bit image contains millions of colours but makes a much larger file than the 256 colour 8-bit version (below).

A single pixel can register at least 256 levels of light in varying tones of grey - usually called grayscale. If a computer is to store this information, it needs to be converted into language that a computer can understand. This language, in simplest terms, is the language of an electronic switch being turned on and off. Off is represented by 0, and on by 1.

The language of 0 and 1, properly called binary, is universal to computers. Binary numbers are described as having bits, that is, combinations of 0 and 1. Our 256 possible light values, expressed in binary, convert to an eight-bit number. Multiply this by three for the three colours – red, blue and green – and you get 24-bits, or 256 levels of red, blue and green respectively – which is what consumer digital cameras

Images which are designed to be viewed on a Web page often need only be in 256 colours (8-bit) because an 8-bit image is considerably smaller than a 24-bit image – even with the same number of pixels. 256 colour images do not look anywhere near as 'photographic' as 16.7 million colour ones.

12

From bits to gigabytes
8 bits = 1 byte
1,024 bytes = 1 kilobyte (K)
1,024 kilobytes = 1 megabyte (Mb) (1,048,576 bytes)
1,024 megabytes = 1 gigabyte (gig) (1,073,741,824 bytes)
Strictly 'kilo' is one thousand, but because computers use a binary system (pairs of numbers) each number is doubled: 2; 4; 8; 16; 32; 64; 128; 256; 512; 1,024

Digital storage

If a digital camera is set to record images at 1200 x 1000 pixels, then the charge levels of 1,200,000 individual photosites have to be sampled and converted into values which can be stored digitally. Often these are tweaked slightly along the way by

and genuinely high resolution CCDs, with as little mathematical guess work from the machine as possible.

Images are usually *compressed* when they are stored, which means they take up less memory space, but retain most of their information. Increasing the compression enables more images to be stored but the quality is correspondingly reduced.

See also pages 20-23 and page 170 for more information about digital camera capability.

More is less: JPEG compression levels affect image quality. **Left**, *low compression;* **below**, *high compression leads to loss of detail and 'artefacts' (see inset enlargement).*

13

the cameras internal software to give the best results. In other words, the camera tries to make the 1,200,000 corresponding pixels of the recorded digital image as faithful as possible to the original scene. Not everyone is agreed as to the best way of achieving this however, and the best results usually come from cameras that have a combination of high quality optics

In addition to internal memory, most digital cameras come with some kind of *removable storage media*. This is generally in the form of a memory card, which can be ejected from the camera and read by a computer, either via an internal or plug-in external card reader or by means of a device such as the Fuji Flashpath Floppy Disk Adaptor. Once the images have been transferred to the hard drive, the card can be erased and can be reused infinitely. This flexibility has lead to such cards being referred to as *digital film*. The two systems currently in favour are Compact Flash and SmartMedia. Both are available in various capacities, currently from 2 to 64Mb and rising.

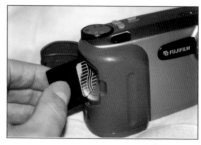

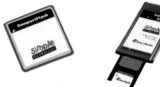

If there is no removable media, the images can be transferred directly to the computer via a serial lead. This can be slow, however, and means loading

Digital film provides limitless memory expansion for cameras.
***Top**, Fuji DS7 with SmartMedia card half removed; **above left**, CompactFlash card; **above right**, PCMCIA adaptor (available for both SmartMedia and CompactFlash).*

14

special software on to the computer first. Infra-red transmission is fast and cheap to install, but only the very latest desk-top machines come with it as standard. *USB* (Universal Serial Bus) is a recent improvement of the serial connection, and is much faster and easier to use, and *FireWire*, from the world of Digital Video, is the fastest direct connection currently available. Digital camera manufacturers are exploring all these routes and have yet to settle on a standard.

COMPARISON CHART

Human Eye	about 120 million pixels
Colour TV (PAL)	200,000 pixels (320 x 625)
35-mm transparency :	opinions vary, but something like 20 million pixels
Digital cameras	budget models (640 x 480) give 310,000 and up to about 6 million on high-end cameras

Resolution confusion

The quality of an image (or more specifically its size), whether on a monitor screen or printed out, depends mainly on its *resolution*. Generally speaking this means how many pixels are used to make up the image, but the word resolution can refer to different things in digital imaging, so often it is important to be more specific.

Image resolution

All digital images are a certain number of pixels high by a certain number across, say 1200 x 1500, but this doesn't tell you the *size* of the image. For that, you need to know the *output resolution* of your printer or monitor, which is usually given in DPI (dots per inch). Colour printers' quoted resolutions vary from about 360dpi to about 1440dpi, but this is not the figure you should use when calculating maximum print sizes. This is because of the way colour printers (and especially inkjets) work; all the colours in your image are created by patterns of just three, four or occasionally six inks (see pages 114-115). As a rule of thumb you should use a figure of a quarter to half the printer's resolution for your calculations. In fact, most digital imaging experts work at a 240-360dpi resolution as this tends to give photorealistic results whatever the printer type. Taking 300dpi as a good average, how big will your digital images be printed?

Taking as our first example a VGA (640 x 480 pixel) image from a low end digital camera:

Dividing the height and width in pixels by our print resolution of 300dpi gives 640 / 300 = 2.13 inches by 480 / 300 = 1.6 inches.
Not very big you'll agree!

If you were printing on a black and white laser printer, however, the images need only be about 150dpi (even the best laser printers cannot deal with images over this resolution), meaning your picture could be about 4½ by 3 inches, which is a bit more usable.

Let's go to the other end of the spectrum and look at a 1280 x 1600 pixel image (such as a top-end digital camera or mid-range scanner might produce).

Working at 300dpi the sizes come out at 1280 / 300 = 4.26 inches by 1600 / 300 = 5.33 inches.

If you were printing this image on a 360dpi inkjet printer you could easily get away with a 200dpi resolution, resulting in:
1280 / 200 = 6.4 inches by 1600 / 200 = 8 inches.

In fact, most people find they are still happy with the results they get from completely ignoring these 'rules' and printing at as low as 100dpi – the advice as usual is to experiment with your pictures on your printer to find just how big you can go.

15

Opposite, camera resolution affects how big an image can be printed
Top, *640 pixels high*
Middle, *1280 pixels high*
Bottom, *1600 pixels high*
(all reproduced at 300 dots per inch).

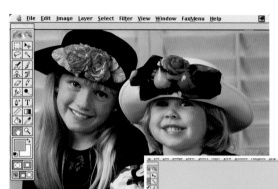

Display resolution affects image size on screen: **left,** *640 x 480 pixel image displayed full size on a VGA display;* **below,** *same image as seen on an SVGA screen.*

Many people will tell you that computer monitors are universally 72dpi and that all images seen on screen will reflect this. The number is actually a hangover from an old Apple format and, although it is still officially the standard, the newer 17-, 19- and 21-inch monitors mean that resolutions from 50 to 96dpi can be found. To make things easier, most images which are intended for screen use (like Web pages) will be standardized at 72dpi (72dpi is also the resolution most digital camera images come out at). This figure is called the *screen resolution.*

The *display resolution* is given as pixel ratio, not pixels per inch. So, for example, 1024 x 768 (known as XGA) or 800 x 600 (known as SVGA) tells you how many pixels will fill the whole monitor screen. If your digital image is XGA (1024 x 768 pixels), and your display is also 1024 x 768, then the image will perfectly fill the whole screen at 1:1 ratio: i.e. 1 pixel in the image means 1 pixel on the screen.

It ís worth checking that your monitor is set up correctly as this doesn't happen automatically. Make sure it ís showing millions of colours (24-bit) with a resolution of at least 1024 x 768 for a 17-inch model (most modern monitors can

work at a variety of resolutions and bit-depths).

Camera resolution
The resolution of a digital camera is all important and represents the main difference between budget and professional models, with prices to match.

The first digital cameras were less than 640 x 480 pixels and often gave disappointing results when the images were printed. Two buzz words quickly became common, namely *megapixel* and *multimegapixel.* Over a million pixels (say 1100 x 1300) means images can be printed up to about 6 x 4 inches and be clear and sharp. Over 2 million pixels *(multimega)* is nearer (but still not quite) 35-mm film resolution. The quality of the camera's optics plays an important part though, as does the way the camera processes the image prior to storing it. Also, it ís worth bearing in mind that a 1.5-million pixel image may actually look fine as a wall-

mounted A4 print, because it will be seen from further away. By far the most important fact to remember is this: all other things being equal, image resolution determines one thing only – output size. A megapixel camera with a poor lens or exposure system will just produce bigger poor-quality images.

Software

In order to manipulate the downloaded images, suitable software will be required. The range is vast, however: from the simple image viewers supplied with the camera to programs such as Adobe PhotoShop, which is the industry standard image editing title but costs about £700 for the latest version. In between, there is an ever-increasing list ranging in price and flexibility considerably.

Most popular packages, such as PhotoSuite, start at around £50 and many of the projects in the second half of this guide use this package. Which is right for you will depend on your requirements and expertise, so it is a good idea to make the most of try-before-you-buy or shareware versions.

Calibration

Maintaining the same colours from the photographed scene, through the computer and monitor, and out via a printer can be a tricky process. The most sophisticated image software (such as Photoshop) allows the user to calibrate the system, especially the monitor, to keep things consistent throughout. Trial and error is employed even by graphics professionals, so don't be surprised if your colours need a nudge from time to time.

Above, software like PhotoSuite will enable you to get the most from your digital pictures.
***Below**, FujiNX-5D Thermal Autochrome prints directly from a SmartMedia card.*

Photo printers

Inkjet printers are currently cheap to buy and give excellent results as long as you use the right paper. The printer manufacturers often supply their own paper which of course they claim gives the best quality output, but it is worth experimenting as there is a wide choice and the difference can be remarkable. New printing technologies are being developed all the time: for example, *Thermal Autochrome* from Fuji and *MicroDry* from Alps both give you realistic photos from your computer; there are more major developments in the pipeline but, as this book goes to press, thick, glossy photo-realistic prints can be made at home for less than you'd pay in a commercial processing outlet. See also pages 114-115.

17

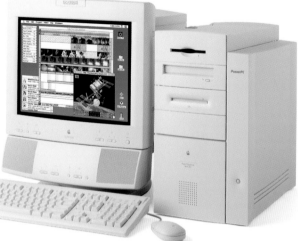

Right, Apple Macintosh computers, long the choice of graphics professionals, maintain their popularity due to fast processors and ease of use. Prices are above PCs but the gap is narrowing.

18

The two main types of home computer currently available are the PC and the Apple Mac. We cannot recommend one over the other for digital imaging, as to a large extent it is a matter of personal choice and compatibility with friends and colleagues' machines. However, here are the basic points to consider.

The IBM PC

The PC currently has over 90 per cent of the computer market. When you consider that owning a computer usually entails *upgrading* it in some way, either by adding new hardware such as a scanner or just buying new software, then the sheer dominance of the PC and Windows 95/98 (the operating system that runs the programs) means you'll never be left out in the cold. Over 5 million software titles (everything from games to corporate and management analysis) are now available for Win95/98 and that fact alone sells many PCs. The machines are generally cheaper than Macs too, although the latter has a better reputation for ease of use.

Specifications

Computers have a nasty habit of costing half what you paid for them a month or two later, and usually for a more powerful machine. A ten-year-old car can be

perfectly useful, but a ten-year-old computer is certainly not. The only answer is to buy the best you can afford: the current top machine will last the longest and will be the easiest to upgrade. For digital imaging purposes, the following minimum specification is recommended:

Processor
Pentium II 400Mhz or faster

Memory
128Mb of 10ns SDRAM

Motherboard:
should have BXí after the name. This will be 100Mhz and support AGP graphics cards.

Hard Drive
8Gb or larger ULTRA DMA-33 or 66

Video Card
8Mb AGP card will compliment the above, but any which allows at least 1024 x 768 in 16 million colours.

Monitor
at least 17-inch, preferably 19-inch or larger as imaging software invariably requires a lot of space.

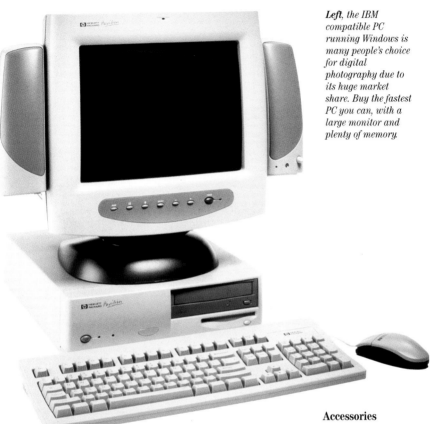

Left, the IBM compatible PC running Windows is many people's choice for digital photography due to its huge market share. Buy the fastest PC you can, with a large monitor and plenty of memory.

19

Monitors

Nineteen- and 21- inch monitors are considerably cheaper than a few years ago, but still can cost into four figures. It seems like an extravagance, but image software needs a good deal of room as the image itself will be surrounded by toolboxes, pull-down menus, not to mention a host of brush and palette selectors. Things can get cramped quickly and you will probably spend hours (years, even) looking at your monitor, so it pays to invest. A monitor's *dot pitch* is also paramount as it represents the sharpness of the display: a figure of 0.25 or smaller will be suitable for imaging.

Accessories

In addition to the computer, there are many peripherals and gadgets aimed specifically at digital image enthusiasts, and the range is growing and improving all the time. Artpads, for example, which are a more subtle input device for the computer than a mouse, and work more like a pen and paper (try writing your name with a mouse) recording how hard you press as well as the direction.

Left, Wacom ArtPad.

Digital cameras come in many shapes and sizes and can cost anything from under a hundred to many thousands of pounds. Although features and specifications vary widely, the underlying technology is always the same, and all digital cameras have the same basic components. No matter how basic or advanced the camera, you will always find a lens, viewfinder for composing shots, a CCD (Charge Coupled Device) for capturing the image, and some form of memory with which to store it.

In addition, all but the most basic entry-level cameras have an LCD monitor on the back for colour previewing and reviewing of images, plus a built-in electronic flash

The CCD
At the heart of the digital camera lies the CCD - the device that converts light falling on to it into an electrical signal that computers can work with.

Zoom buttons

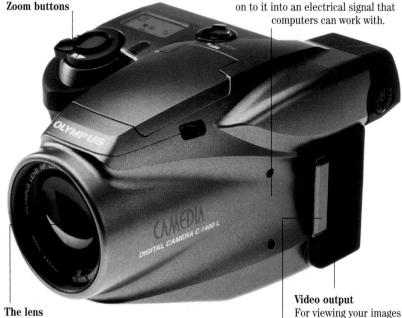

The lens
Whether fixed, autofocus, wide-angle or zoom, the lens performs the same task: to focus the light reflected off the subject on to the CCD, creating a sharp image. Lens quality can affect both sharpness and colour balance, but has no effect on image resolution. *See pages 24-25 and 110-111.*

Video output
For viewing your images on a television screen *(see pages 32-33).*

Serial port
Still the most common way of pulling images off the camera's memory into a PC. Attaches via a cable to the comms port (PC) or Serial port (Mac).

for low-light photography. It is unusual these days to find a camera without some form of removable media – the mini memory cards that extend the camera's capacity, allowing you to take as many pictures as you want without having to return to your computer to download.

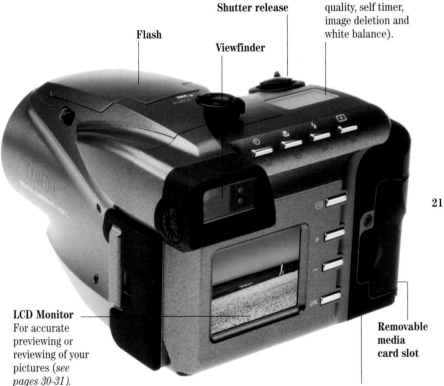

LCD info/control panel
For accessing the camera's controls (such as image quality, self timer, image deletion and white balance).

Shutter release

Flash

Viewfinder

LCD Monitor
For accurate previewing or reviewing of your pictures (*see pages 30-31*).

21

Removable media card slot

Battery compartment

Left, *Fujifilm's autofocus DX-9 Zoom digital camera. The 3x zoom lens is equivalent to a 32-96mm zoom.*

Here is an approximate guide to what you can buy for your money.

UNDER £100

Basic VGA resolution camera (640 x 480 pixels) or lower with no removable media. Rarely with LCD monitor.

Agfa ePhoto 780c – a basic VGA camera.

£100-£300

Top-of-the-range VGA cameras with zoom lens, LCD monitor and removable storage; basic XGA (1024 x 768) cameras without zoom.

Fuji DX-10 – inexpensive Autofocus XGA model.

£300-£500

Top-of-the-range XGA cameras with zoom lens and extra features; mid- to high-end megapixel (1024 x 1280 or 1024 x 968) cameras with fixed or zoom lens and plenty of features; entry-level non-zoom 2 megapixel (1200 x 1600 or 1200 x 1800) cameras.

Sony MVC-FD91 – sophisticated XGA camera with floppy disk storage.

£500-£750

Top-of-the-range megapixel cameras; 2 megapixel zoom cameras, often with true photographic controls.

£750-£1000

Top of the range 2 megapixel (or more) cameras with a useful range of features.

Fuji MX-1700 – entry-level 1.5 million pixel zoom camera.

£1000+

Cameras with resolutions over 2.5 million pixels and professional single-lens-reflex models (from around £3,000).

Olympus C-2000 – 2 megapixel zoom camera.

Nikon Coolpix 950 – 2 megapixel with zoom and manual controls.

Left, Kodak DC240 – mid-range
1.2 megapixel camera with
2x optical zoom.

Right, Kodak DC220 –
high-end megapixel
with 2x optical zoom
and scripting
capabilities.
Far right, Kodak DC
260 – as DC220 but
with 3x optical zoom.

Below, Minolta RD175 – mid-range
professional 1.75 million pixel
single-lens-reflex with
interchangeable
lenses.

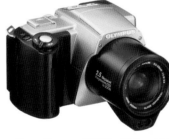

Above, Olympus C2500L – high-end 2.5
megapixel SLR camera with built-in
3x zoom and full photographic controls.

Below, Nikon D1 – fast high-end
professional SLR with
interchangeable lenses.

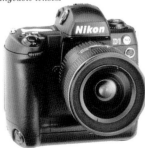

Above, Fuji DS330 – high-end semi-
professional megapixel model with built-in
3x zoom lens.

Top, wide angle; above, telephoto.

A good lens can make all the difference between a mediocre photograph and a real eye-catcher – a poor lens will be the downfall of even the best CCD.

Happily most digital cameras are made by manufacturers with a long history of developing optics that can deliver sharp results whatever the recording medium.

Focal length
The focal length of a lens affects the angle of view of your pictures – a short focal length creates a wide angle effect, whilst a longer focal length has a much higher magnification, creating a telephoto effect, similar to binoculars or a telescope. When the focal length of a lens (measured in millimetres) roughly matches the diagonal size of the film or CCD sensor being exposed, then it is called a standard lens. The standard lens for a 35mm camera usually has a focal length of about 40-50mm (the diagonal of a 35mm film being around 43mm). This gives a field of view roughly equivalent to the human eye.

Most people are nowadays familiar with the zoom lens – one with a variable focal length. A zoom lens significantly increases the versatility of a camera and widens

considerably your picture-taking possibilities. Whilst a zoom lens on a 35mm camera will usually be defined by its focal length range (i.e. 35-135mm), digital camera zooms are often referred to by their magnification range (e.g. 3x or 12x). A 12x zoom (found on a few models) is roughly equivalent to a 38-460mm lens on a 35mm camera. All digital camera zooms are motor powered – you just press the wide and tele buttons to frame your scene. The LCD monitor and/or viewfinder will show the angle of view as it changes from one end of the range to the other.

Digital camera lenses
Most low-to medium-cost digital cameras have fixed lenses – their focal length cannot be altered – meaning you only get

one angle of view. Fixed lenses are usually of a modest wide-angle design as this is considered by many to be the most versatile lens type, allowing both landscapes and close-ups.

Increasingly, manufacturers are including zooms on their digital cameras, but interchangeable lenses are still only found on very expensive professional models.

Focal length equivalents

Because the angle of view of a lens depends on whether its focal length is shorter or longer than the diagonal of the CCD, the actual focal length in mm used will depend on the size of the sensor. If you want to create a wide-angle lens for a 35mm compact (image diagonal about 43mm) you will use a focal length of, say 28 to 38mm. Digital cameras typically use CCDs with a diagonal measurement of between 6 and 11mm, meaning that a 35mm lens would represent quite a considerable telephoto on most digital cameras. The fixed lenses on digital cameras tend therefore to be between 5 and 10mm, again representing a modest wide-angle. Because we are now so familiar

Above, standard.

with 35mm camera lens lengths, most manufacturers quote *35mm equivalents* when talking about their lenses. Thus, a small zoom on a digital camera with a range of 5-15mm, may be quoted in the sales literature as a 35-135mm (equivalent). Until CCD sizes and public awareness of digital cameras increase significantly, however, the 35mm equivalent system is likely to stay around.

Maximum aperture

Although apertures are rarely manually controlled on basic digital cameras, the maximum aperture is of great importance. Put very simply, the aperture is the hole through which light enters the camera. The bigger it is, the more light can get through. Aperture is measured relative to the lens focal length as an f-number with a smaller f-number letting more light through than a large one. A lens with a very large maximum aperture is traditionally described as fast: f1.9 is an example of a fast maximum aperture and is much better at low light and for action photography than a maximum aperture of f4.

Left, off-centre subjects fool autofocus systems into focusing on the background. Use half pressure on the shutter to lock focus and then re-frame.

when the button is half depressed and the camera then gives some form of confirmation that it is okay to shoot (usually a green light and/or beep).

It is often possible to check the autofocus visually, using the preview monitor – if available.

No matter how good a lens is, it still needs to be focused on your subject, or everything will be a blurry mess. Digital cameras achieve this in one of three ways.

Fixed focus
Used in most simple digital cameras, the fixed lens is pre-adjusted to give sharp results over a wide range of distances (typically from a few feet to infinity). Although very convenient, the downside of fixed focus lenses is that they are rarely very fast and there is no opportunity for selective focus (*see pages 48-49*).

Zone focus
Less common than fixed focus is zone focusing. The lens is focused manually by turning a dial to a zone usually represented by icons representing close-up, portrait, group shot and landscape (or similar). The advantage of zone focusing is that the lenses can be faster and can usually focus closer than a fixed focus lens. Selective focus is available to an extent, but the lack of aperture control is a limiting factor. Zone focus cameras have all but disappeared giving way to...

Auto focus
Most new digital cameras have an automatic focusing system. Generally, the camera will focus on whatever is in the centre of the frame when the shutter is pressed, and most are very accurate. The distance to the subject is usually measured

As with any automatic system, autofocus is not foolproof and it's probably worth remembering a few simple rules-of-thumb when using your camera:-
The camera needs some contrast to focus: if your subject is lacking in contrast or is too bright or dark, try finding something at a similar distance that is easier for the camera to find. Then you can lock the focus (see below) before re-framing and shooting. Autofocus systems also hit problems when photographing through glass (in which case, you should choose the *infinity* or *landscape* setting if your camera has one).

The camera will always focus on the dead centre of the frame. If your subject is not in the centre, the camera will miss it completely and focus on the background. To avoid this, use the focus lock, usually activated by a half pressure on the shutter release. Simply point the camera at your subject and half press the button (and keep it depressed). The focus will now be locked at your subject's distance until you lift your finger again. You can now re-frame with the subject off-centre, safe in the knowledge that the camera will not re-focus and ruin the picture.

Manual overrides
There are times when the only answer to photographing 'difficult' subjects is fully manual focus. Few non-professional digital cameras offer this option, which consists of either using your own eye to assess when you have the lens in focus, or manually

26

Left, wideangle lenses and small apertures give a large depth of field; everything is sharp from foreground to background.

Below, longer lenses and wider apertures give a much narrower depth of field; here this is used to good effect as it effectively isolates the subject from the background.

entering the distance you want in feet or meters. Many photographers will tell you that manual focusing is the only truly creative way. Not true. An efficient autofocus system which allows you to check whether the focus is accurate (either on the LCD screen or through a reflex viewfinder) is highly convenient because it frees you to concentrate on the important bit – composing your picture.

27

Depth of field & selective focus

When a lens is focused on a particular distance, say 15 feet, there is a zone either side of that 15' point that also appears sharp in the photograph. The size of this area of focus is termed the '*depth of field*'. Depth of field depends on two factors: aperture and magnification. The wider aperture the smaller the depth of field, and thus the smaller the zone of sharpness around the subject. Similarly, the greater the magnification, the smaller the depth of field. In practical terms, this means that wide-angle lenses (low magnification) have a much greater depth of field than telephoto lenses, when using the same aperture. In bright light (when very small apertures are used) depth of field is increased up to the point where, with a relatively wide lens, the depth of field is so great that everything from a few feet away right up to the most distant mountains will

be captured in sharp focus. This is the principle upon which fixed focus cameras are based.

Conversely, when using longer lenses with wider apertures, depth of field is very limited – possibly only a few feet or less. This allows the photographer to isolate his subject from the rest of the scene by dint of it being the only thing in focus. This technique is especially suited to portraiture where it can be very successfully used to isolate your subject from a disturbing background. As digital cameras usually offer no control over apertures there is no easy way to ensure a narrow depth of field for portraits using the telephoto end of a zoom. Two tricks worth trying on a bright day: use neutral density filters to cut the amount of light entering the lens, or use the flash outdoors – both will force the camera to use a wider aperture.

As well as a lens to focus it, the camera must also control how much light falls on the sensor, and how it happens.

There are only two variables at work regarding the quantity of light falling on to the CCD: intensity and duration, or 'how bright and for how long?'

Digital cameras, like conventional cameras, control the flow of light on to the CCD by means of aperture and shutter speed. These are usually controlled by the camera's CPU (Central Processing Unit – the 'brain'), which calculates the correct combination based on the sensitivity of the CCD, together with a measurement of the available light.

Exposure controls

Digital cameras tend to have very simple exposure controls (usually nothing more than a +/- setting for when the camera fails to get the exposure right first time). Exposure compensation settings usually

range from -1.5 stops (picture gets darker) to +1.5 stops (brighter). With particularly awkward subjects (or ones with a very wide range of brightnesses) the camera may set the exposure incorrectly, and exposure compensation can be used to put things right again. By its nature this can involve a certain amount of trial and error.

If your subject is relatively small, and considerably darker than the rest of the scene (such as someone in front of a sunset), the +/- settings provided may not be adequate and you may need to use fill-in flash (see opposite page).

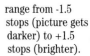

Manual override

Many of the latest 2 million+ pixel cameras for the first time offer the kind of manual overrides and exposure controls that most photographers take for granted on film cameras. Aperture and shutter priority modes, extra metering patterns and other controls are now much more common than before, although the level of sophistication is still short of similarly-priced film SLRs. Some mid-range cameras offer different exposure modes (such as action, landscape, portrait) which give the aperture/shutter speed combination the right bias. On cheaper cameras they may not be so reliable and, if your camera offers these settings, it is well worth investigating how well they work.

Screen brightness

Where the brightness of the LCD viewing screen can be altered (by a dial or on-screen option) it is important to remember that this affects *only* the screen. The photograph taken will not change its brightness at all.

White balance

In nature, light comes in many colours and the human eye tends to be very forgiving about this. Natural daylight is very cool, with a distinct blue cast. The light from a 100-watt light bulb is very orange. Yet because your brain can rapidly compensate for colour casts, a sheet of white paper looks white to your eyes in either situation. Cameras, too, can compensate for different light sources, by means of the white balance control. Auto White Balance (AWB) will try and show a sheet of white paper as white whatever the colour of the lighting, and it usually works. Many cameras offer the user control of white balance and this can be used for effect (for example to create a warmer tone when shooting under tungsten lighting).

Flash controls

All but the most basic digital cameras offer a built-in flash for low light situations.

Most mid-range digital cameras offer an automatic multi-mode flash. An automatic flash will fire whenever the available light falls below a certain value. The multi-mode bit means you can take control and override it.

The three most common flash modes are auto, fill-in (or force-on) and off. There are times when the camera may be fooled into thinking that the flash is not needed, most commonly in 'backlit' situations (where your subject is in front of a much brighter background, say a window). If you do not use the flash in these circumstances, you will get a silhouette of your subject – not much use for portraits. Conversely, shooting a sunset can fool the camera into firing the flash, so sometimes it is important to remember to turn it off. This also applies when shooting indoors if you want the warm, slightly blurred effect achieved by turning off the flash. Most cameras cannot vary the power of the flash enough to use it for very close subjects (and many will disable it when using the macro mode).

Anti red-eye

When shooting with on-camera flash it is difficult to avoid the dreaded 'red-eye' caused by light reflecting off the retina. Like most conventional 35mm models, many digital cameras offer red-eye reduction flash modes. This usually consists of a pre-flash to close the subject's irises before the main flash. However, red-eye reduction is no more than a palliative – it does not solve the problem completely. The answer is to remove it on your PC, using a graphics application – just one of the many advantages of digital photography over conventional photography.

29

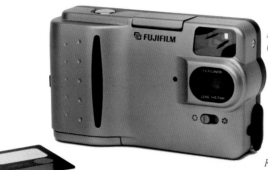

Fuji DX-5
(optical finder only).

Fuji DX-9 (optical & LCD).

Composition is where the art starts, and digital cameras offer a variety of ways to see what you are shooting.

Optical finders
Just like conventional 35mm cameras, many digicams have an optical viewfinder, ranging from the simplest framing aids (basically just a rectangular hole) to the bright zooming finders found on top models.

Advantages: An optical finder creates no extra drain on the already hard-worked batteries. They are bright and easy to use, whatever the lighting and lens used.

Disadvantages: You are not seeing exactly what the CCD sees. This can cause small framing errors (called parallax errors) which increase as you get nearer to your subject. Most viewfinders have 'parallax marks' etched onto them to allow you to compensate for the difference when you frame your picture. It is advisable to be aware of these markings and to use them wherever possible, but especially on any subject closer than about 6 feet away. The most advanced zoom cameras have finders that automatically adjust to show the correct framing area for the focal length/distance chosen.

LCD monitors
One of the features unique to digital cameras, an LCD monitor will show you in colour exactly what the CCD is seeing through the lens. On most models, when you press the shutter the moving picture on the screen will freeze to show you what the picture just taken looks like.

Tip: use the viewfinder and LCD together to save batteries
If you use a digital camera's LCD for previewing images (i.e. you frame with it) you will soon find that battery life becomes a major headache. If your camera has both LCD and optical finders, the solution is to use the optical viewfinder for taking the picture, and then check the image taken as it appears on the LCD. Most cameras will allow the LCD to be turned off (in fact you usually need to switch it on to use it). For most everyday photography you will not encounter serious parallax errors, and the battery life savings will be huge.

Advantages: What you see is what you get – no framing or focus errors, plus you are not restricted to holding the camera up to your eye. You can take pictures around corners or inside small nooks and crannies or even over the heads of a crowd and still be able to see the screen. Cameras with a rotating lens allow easy self-portraits and candid shots. Instant feedback lets you check that you got the shot you wanted.

Disadvantages: LCD monitors eat batteries. Keeping the camera still and horizons perfectly straight is more difficult working at arm's length. The monitor tends not to work well in very low light (nothing appears on the screen), or very bright sunlight (you can't see the image on the LCD).

Single lens reflex

Still quite rare in digital cameras, this system allows you to view the scene as the CCD will see it by a system of prisms and mirrors. Although preferred by professional film users, the SLR system is possibly less relevant to digital cameras, as an LCD monitor allows through-the-lens framing without adding any bulk.

Advantages: Very familiar to conventional photography enthusiasts and professionals. Perfect framing as with the LCD monitor. Allows through-the-lens

Minolta Dimâge V (LCD only).

composition with the camera held to the eye. Much lower battery drain than an LCD. Usually allows the use of add-on filters and lenses.

Disadvantages: Unless used with an LCD, you don't get the instant feedback of seeing your shot on screen. Bulky.

31

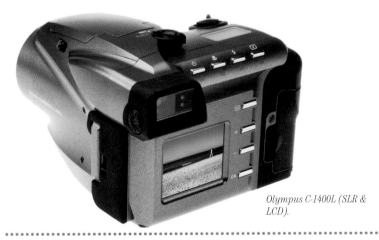

Olympus C-1400L (SLR & LCD).

PLAYBACK CONTROLS ...

Checking your pictures before downloading saves time and allows re-shooting of photos that didn't work.

Cameras with an LCD monitor usually offer three playback options:
 Single frame: each recorded picture is shown full screen – you scroll through them sequentially, using the arrow or +/- keys.
 Multi frame: images are shown in groups of six or nine. The 'thumbnails' can be highlighted using the same keys as above and viewed full-screen
 Slide show/Auto playback: Images are shown one after the other with a few seconds' pause between each frame.

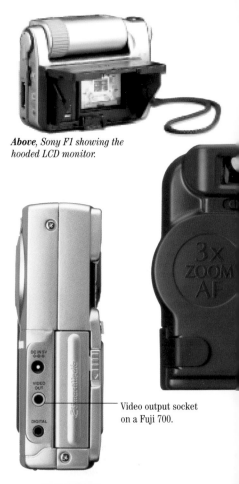

Above, Sony F1 showing the hooded LCD monitor.

Delete and protect controls
Images can be erased in order to free memory space. This is usually performed by choosing a menu option in the playback mode. Images can also usually be protected to avoid accidental deletion.

Video output
If a digital camera offers a video output socket, all the playback (and preview/review) functions can be watched on a television or recorded to video tape. The live output of some digital cameras means they can be used as tethered video cameras (without sound).

Video output socket on a Fuji 700.

32

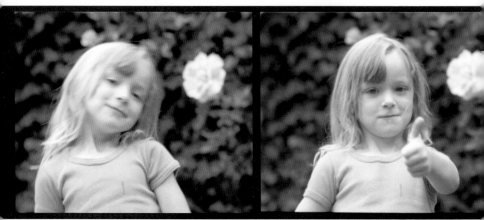

Right, after downloading, one of the selected pictures has been retouched in PhotoSuite 11 to remove the distracting yellow rose and other small blemishes.

Below, an LCD preview/review monitor allows you to immediately check your shots and delete any unwanted ones.

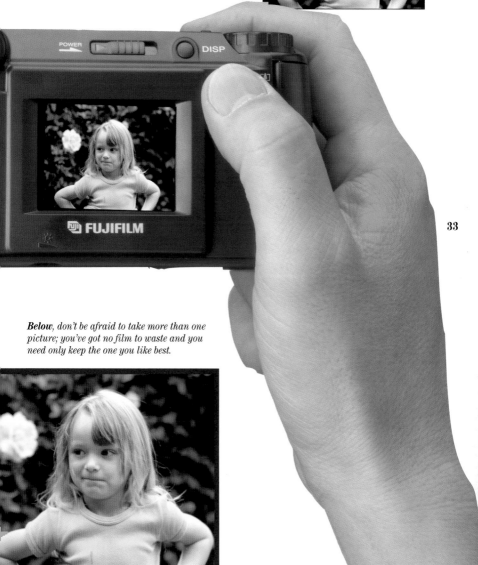

Below, don't be afraid to take more than one picture; you've got no film to waste and you need only keep the one you like best.

Digital cameras vary widely in their sophistication. Below is a selection of some of the other controls on offer.

Picture effects

Anything from pastel effect to black and white to cartoon effects can be found on various digital cameras. It is worth bearing in mind that most of these irreversible effects can be created in seconds using a computer and graphics software – so getting the camera to do them simply eliminates any possibility of doing anything else with that shot.

Picture sharpness

Digital cameras that allow control over the camera's default picture enhancement settings are beginning to appear on the market. These can include contrast, colour balance, saturation and sharpness. Experiment with the various settings to discover which suits your photography best. Again, remember that post processing is what sets digital photography apart and most of these enhancements/ adjustments can be made later in software.

Sound recording

Allows you to annotate images with a spoken description which is downloaded with the photo as a sound (.WAV) file.

Above and *right*, *display of in-camera picture effects.*

.Below, *Fuji 700 features display.*

34

Multi frame

The camera takes a burst of low-resolution images (usually four, nine or 16) in about a second, allowing you to capture fast action (similar to a conventional camera's motordrive). These mini frames can sometimes be combined to make a small movie file that can be replayed on your PC.

Picture quality setting

Digital cameras always offer at least two 'quality' settings, often more. The only reason for not using a camera at its best possible quality is simple: memory space. Image files are large (a standard 640x480 pixel image occupies nearly a megabyte) and all cameras use a form of compression (usually JPEG, see page 170) to

Left, a multi frame sequence.

squash files down to a more manageable size. The process of squashing has a detrimental effect on image quality because the camera 'throws away' some information in the process. The standard, fine and superfine modes are usually just different levels of compression that allow you to play off quality versus how many images can be stored. Some cameras even offer a completely uncompressed mode that gives the maximum possible quality but uses up a huge amount of memory.

Resolution setting

The other way to reduce image file sizes (see above) is to shoot at a lower resolution. For example, a camera with a 960x1280 pixel chip may offer a lower

resolution setting of 640x480 pixels. The reduction in file sizes will allow up to four times as many pictures to be

stored on the camera's memory card. When combined with the higher level of compression of the standard quality setting, it is possible for a camera to have a range of settings that allows hundreds of low quality pictures to fit on to the same card as one or two of the best.

Which setting to use?

If you intend to print your images, or use them large on screen, then do not use the lower resolution setting. Remember, you cannot put back what was never there.

The compression question is slightly more difficult. Again, the only way of getting the best possible photos from your camera is to use the superfine mode, but this may only allow four images to fit on to each card – not much use for a day's photography. The only answer is to experiment: the effect of compression varies according to the subject of the picture, the camera's resolution and the system used. You may find little discernible difference between fine and superfine modes. If so, use fine for most of your shots. Avoid the standard setting as this tends to degrade the picture quality too much. Cost considerations aside, if your camera has a removable media option, buy some extra cards. This should stop the temptation to squeeze in more shots by using the lowest quality setting you can get away with.

35

The nature of a digital photographer is that of a magpie - always looking out for eye-catching images that can be later combined with others and incorporated into a whole that is far greater than the sum of its parts. Much is talked about the digital photographer building a library of image-parts that might come in useful later, but what if you already have a library of photographs in the form of films and prints produced using traditional methods? Few digital camera owners will have got this far without taking some traditional photos, and it seems a pity to consign them to the cardboard box under the stairs when you'd really like to try some of your digital imaging software out on your favourite existing photos. Maybe you could even improve on the originals now you have the benefit of all this computer wizardry!

Fortunately the process of digitizing your old photos ('scanning') is a relatively straightforward affair, and it all revolves around a scanner.

Scanners come in a huge variety of shapes and sizes, and with prices ranging from about $40 to $40,000 it can be a bit of a minefield for the uninformed buyer.

How do they work?

Whatever the type of scanner the basic principle is the same: a thin CCD sensor is passed along the original, recording it a line at a time. In a flatbed scanner the original stays still on the glass platen whilst the CCD is slowly moved along its length, accompanied by a bright fluorescent tube. Film scanners (usually) have a fixed CCD and light source whilst a special holder gradually moves the film, allowing the scanner to build up the entire picture. The information from the scanner is then passed along a serial cable to the controlling PC which records the image, either into its RAM or directly onto the hard disk.

36

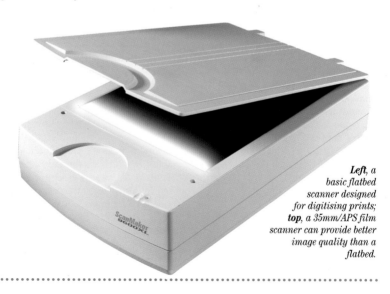

Left, *a basic flatbed scanner designed for digitising prints*; *top*, *a 35mm/APS film scanner can provide better image quality than a flatbed.*

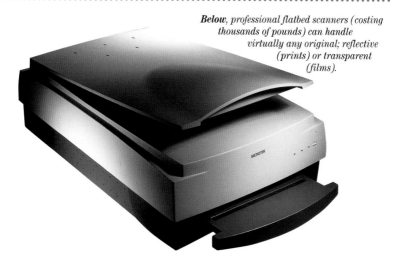

Below, *professional flatbed scanners (costing thousands of pounds) can handle virtually any original; reflective (prints) or transparent (films).*

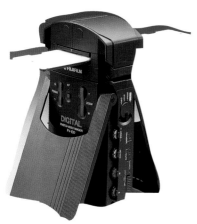

What do you need?

The first consideration when buying a scanner concerns your originals; are they slides or prints (or their negatives)? If they are transparencies, are they 35mm or medium format? Are the prints 6x4 inch or 10x8 inch or bigger?

Whilst there are scanners available that can deal with all types of original from a 35mm neg to a 10x8 inch transparency or 12x16 inch print, these models tend to be too expensive for home use (and often produce below-par results).

37

Left, *digitisers based on video cameras can be very versatile; this inexpensive Fuji unit scans prints, films and solid objects, but quality is not fantastic.*

Right, *dedicated film scanners are now much more affordable and offer superb quality and ease of use for slides or negatives.*

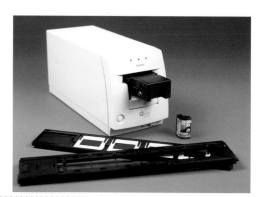

Flatbed scanner

Most photographers' first choice will be a flatbed scanner, mainly due to the very low cost of these units (from about £50 upwards). Although miniature models exist that have a maximum scan area of 5"x7", there is little to recommend them over the similarly-priced A4 models. An A4 flatbed looks like a small desktop photocopier: a glass plate sits on top of the box with a hinged plastic lid holding your originals flat. Flatbed scanners are designed for use mainly with (and sometimes only with) reflective originals: in other words, prints. Because the light source and CCD are on the same side of the original, slides and negatives cannot be recorded without the addition of a 'transparency adaptor'. This replacement 'lid' contains a light source and can cost as much as (or even several times more than) the scanner itself. When using 35mm or 120mm films, few flatbed scanners have the resolution or focus accuracy needed for decent reproduction. When choosing a flatbed scanner, cost is usually the deciding factor. As prices rise, you get a gradual increase in resolution and quality, and finally the addition of a built-in transparency hood. Flatbed resolution (measured in 'dots per inch') is usually shown as a vertical x horizontal figure, i.e.: 300 x 600dpi. Horizontal resolution is a measure of how many pixels there are squeezed into the long sensor, whereas vertical resolution concerns how finely the motors can control the vertical movement of the CCD. When comparing scanners, it is important to check optical resolution as opposed to 'maximum' resolution. Optical resolution is a physical measure of the CCD's output (say 300 x 300dpi), but most

manufacturers include software that artificially ups resolution by *interpolation*. This can result in quoted maximum resolutions of 4800 x 4800dpi or greater.

You should ideally look for a 600dpi or better scanner (about £200 and over), though if you want to use a transparency hood you'll need 1200 x 1200dpi (at least £500 plus the adaptor). Most flatbeds attach via the SCSI port (via an optional £50 card on non-equipped PCs) or the Parallel/Printer port. SCSI connection is many times faster than parallel.

35mm film scanner

If you have a collection of slides, then you may want to consider a 35mm film scanner. Costing from about £399 upwards, film scanners are one-trick-ponies, but they tend to do that trick pretty well. Film scanners can accept either mounted slides or film strips (in special holders) and usually allow you to preview thumbnails of a strip at a time. Resolutions vary from about 1200dpi to 2750dpi. For reproduction at A4 you really need to be nearer the upper limit than the lower one. Again, film scanners attach via the SCSI port (or, rarely, the parallel port).

Over 35mm

The problems start if you use 120 roll film to produce your negatives or slides.

Dedicated multi-format film scanners do exist but, at well over £4000, they are out of most amateurs' reach. Professionals tend to use an outside bureau for this type of scanning, which will use a drum scanner. At £10-£50 a scan (or £1000-£2000 for the scanner), few home users will go down this route.

The only solution is to buy the best flatbed scanner you can afford and use a transparency adaptor. For decent results you will need to budget for about £1500. Alternatively, you could scan from prints,

thus avoiding the need for the expensive adaptor.

Making a scan
Whatever scanner you use, the basic process (controlled by the supplied software on your computer) is the same.

Place original in scanner; pre-scan; adjust settings (resolution, colour balance and cropping) and scan. The scanner software (called a driver) is usually in the form of a *Photoshop plug-in* or *TWAIN acquire module*, so you can bring images directly into your favourite image editor.

SCANNER CHART

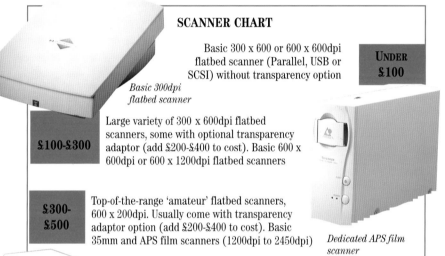

Basic 300 x 600 or 600 x 600dpi flatbed scanner (Parallel, USB or SCSI) without transparency option — **UNDER £100**

Basic 300dpi flatbed scanner

£100-£300 — Large variety of 300 x 600dpi flatbed scanners, some with optional transparency adaptor (add £200-£400 to cost). Basic 600 x 600dpi or 600 x 1200dpi flatbed scanners

£300-£500 — Top-of-the-range 'amateur' flatbed scanners, 600 x 200dpi. Usually come with transparency adaptor option (add £200-£400 to cost). Basic 35mm and APS film scanners (1200dpi to 2450dpi)

Dedicated APS film scanner

39

Semi-professional flatbed scanners (better quality, 1200dpi), all with optional transparency adapter. Mid-range 35mm film scanners. Basic flatbed scanners with built-in transparency hood — **£500-£800**

Semi-professional 35mm film scanners (2700dpi). Mid-range flatbed scanners with built-in transparency hood — **£800-£1200**

Mid-range 35mm/APS film scanner

£1200-£2000 — High-end flatbed scanners with transparency adaptor

£2000+ — Professional (repro quality) flatbed scanners. Drum scanners (£10,000+)

Gathering digital images
– an overview

This section shows how digital cameras and digital image manipulation are changing the face of photography. However, digital cameras often aren't as versatile as conventional cameras. So the following pages are all about overcoming their limitations, while maximizing their strengths.

Not just cameras...

Don't forget, in reading this section, that digital cameras are not the only way of getting a digital image into your computer – in fact they are one of several ways, summarized on these two pages.

PhotoCD
Much higher storage capacity than a floppy disk – see opposite. A processing lab, or a postal service such as Kodak's, puts images on a CD-ROM, delivering in around a week (same as for a floppy). The service is available in the high street either at the same time as you have your film developed or at a later date (although this costs more).

PictureCD
This is a relatively new service offered by Kodak through its film processing outlets. Only available at the time of developing (and only from print films), it puts 1.5 megapixel digital versions of your photos on to a CD-ROM along with free software, articles and tips. The cost is very low (around £10/$16 including development and printing the film) and the system is an ideal starting-point for anyone wanting to get into digital imaging on a budget.

Scanner
Usually the first extra bought by the budding digital photographer. Prints, slides and negatives (depending on model of scanner) can be digitized and imported directly into your computer. See also pages 36-39 and 114-115.

Internet
Register with an Internet processing service such as PhotoCenter's PhotoNet. Take your films to a participating photo lab, who will digitize, uploading to the service's web site. From there, you download into your computer. There is also a wealth of free pictures available for home use on the web.

Floppy disk
If you don't have a CD drive on your PC, this is your simplest route. A processing bureau, or a postal service will put 20 images on a floppy.

Digital camera
See pages 42-111 and pages 20-35. Convenient – since images are directly captured in digital form. Download shots direct to your computer by a special cable, or put the camera's memory card into the computer – if suitably equipped.

Advantages and disadvantages

PhotoCD
✔ High quality possible if original is good.
✔ Stores up to 100 shots if a 650Mb CD.
✔ Less prone to damage than floppies.
✔ Low, medium– and high-resolution scans provided.
✘ Not re-recordable.
✘ Not instant; can wait up to a week for service.
 ✘ Can't use if computer lacks CD-ROM drive.

Digital camera
✔ No film or processing needed – saves time & money.
✔ Some models have picture preview screens: a great creative aid.
✔ Downloading images easy – but can be slow.
✔ Latest megapixel cameras good for 6"x4" or bigger prints.
✘ Poor resolution on cheap models.
✘ Some models store limited number of images.
✘ Edge effects with JPEG compression.

Summary
Scanners and PhotoCD-ROMs offer better image quality for your money than digital cameras or video grabbers, but the gap is closing. On the other hand, digital cameras serve up digital images more or less instantly, without intervening processes.

PictureCD
✔ High-quality images if originals are good.
✔ Very easy to use.
✔ Inexpensive.
✔ Comes with added 'freebies' such as software and articles.
✘ Limited resolution compared to PhotoCD.
✘ Only one film per disk can be digitized.
✘ Only available if ordered at the same time as film is developed.
✘ Doesn't work with slide films.

41

Floppy disk
✔ Use on any computer.
✔ Low-cost conversion and cheap storage medium.
✔ Simple – no need for a cable linking camera and computer.
✘ Disks unreliable.
✘ Capacity too small for large images.
✘ Resolution only OK for small enlargements.

Scanner
✔ Can give range of resolutions, from low to high.
✔ Faster than sending images away.
✔ Choice of image to scan.
✔ Uses different film sizes or prints.
✔ Better resolution than amateur digital camera.
✘ Expense – especially of film scanner types.
✘ Transparency adaptors cost extra.

FOCAL LENGTH

Right lens, right task

The focal length of a lens is a measure of its power and its angle of view. Broadly speaking, lenses fall into three categories: wide-angle, standard and telephoto.

Definitions

Comparative angles of view of popular lenses

135 mm 50 mm 35 mm

A wide-angle lens has a wide angle of view: it will enable you to photograph a wide sweep of the subject in front of you - wider than the field of human eyesight. This has the effect of making the subject seem further away.

A telephoto lens has a narrow angle of view which has the effect of drawing a subject in closer – making it larger in the frame.

A standard lens falls half way between the two and produces an image size, but not an angle of view, which is roughly the same as produced by the human eye, making it appear natural to the viewer.

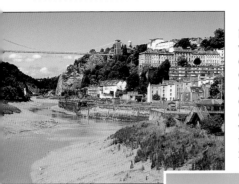

Focal length is measured in millimetres, but in a digital camera what qualifies as a wide-angle, standard or telephoto lens depends on the size of the light sensitive chip which records the image inside your camera. Because of this discrepancy, most camera manufacturers quote digital camera focal length in equivalent sizes as well as actual size. This relates it back to the 35mm format, which most people are familiar with.

Above, shot produced by a digital camera with the zoom set at 8mm – wide-angle. *Right*, with the zoom set at about 12mm.

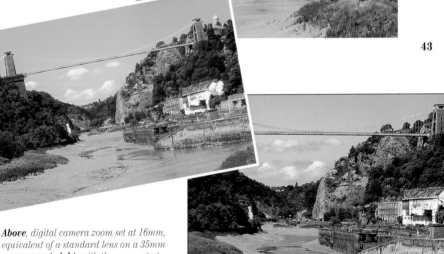

43

Above, digital camera zoom set at 16mm, equivalent of a standard lens on a 35mm camera; and *right*, with the zoom set at 24mm, equivalent of 105mm telephoto on a 35mm camera.

If your digital camera has a fixed lens, it will generally be the equivalent of a 35mm wide-angle lens on a 35mm camera. If it has a zoom lens, then it will generally run from 35mm up to 105mm. For example, the Fuji DS 300 has an actual lens of 8-24mm which equates to a zoom of 35-105mm on the 35mm frame.

FOCAL LENGTH / 2

Characteristics of focal length
Each type of lens will have a given set of
characteristics which affect the image,
making the lens suitable for some uses but
not for others.

A wide-angle lens, with its wide
viewpoint, tends to distort the subject,
especially at the edges. Straight lines tend
not to appear straight and parallel lines
tend to converge. Wide-angle lenses also
disproportionately magnify things which
are close to the lens, distorting the
perspective. They tend to be unsuitable for
portraits, making the nose look too large.

A wide-angle lens can be useful when
you want to exaggerate perspective, as in
this shot of the Taj, which appears to tower
in the frame.

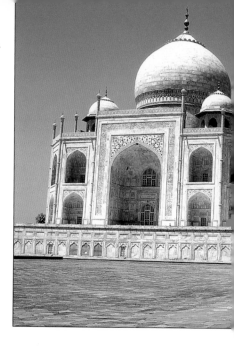

*Below, a wide-angle shot which
works well because the woman
nearest the lens is still not so close as
to suffer from distortion.*

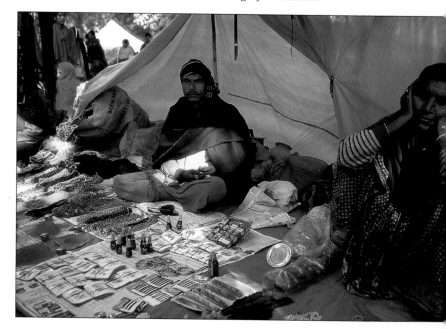

Left, the distorting effect of a wide-angle lens, working to useful effect because it emphasizes the massive proportions of the subject.

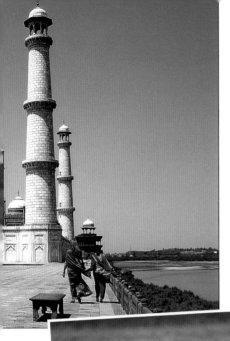

A telephoto lens compresses perspective, making the subject appear solid and imposing. The lens has inherent lack of depth of field, and this helps the subject to stand out from a potentially confusing background. A moderate telephoto lens - equivalent to 100mm on a 35mm frame - produces a very flattering perspective when used for portraits, without any of the distortion of a wide-angle lens.

45

Above, *taken on a simple digital camera with the zoom set at 24mm.*

DIGITAL SOLUTION

If you don't have a telephoto lens setting on your camera, it is possible to shoot the picture with the camera's fixed wide-angle lens, crop the picture on a computer and resample to get to the desired size.

DEPTH OF FIELD

The depth of field of a lens is a measure of how much of a picture will be in focus. When a lens is focused on a particular spot, that point will of course be sharp; but there is also a zone in front of and behind the point which will also appear to be in focus on the final image. This zone is called depth of field.

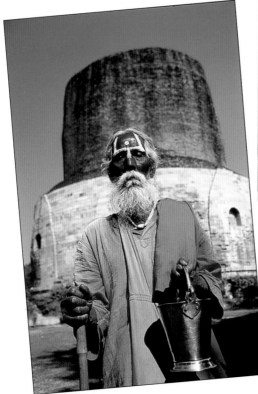

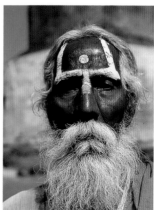

Left and above, the effect of a wide-angle versus a telephoto lens on depth of field can be seen from these images of an Indian Holy man.

Depth of field arises because a lens's aperture - the hole (formed by the 'iris' diaphragm) through which the light shines - itself has a focusing effect. The smaller the aperture, the more pronounced the effect. As most digital cameras don't have adjustable apertures, you probably won't be able to adjust the depth of field by selecting a narrower aperture, but there are still a number of ways of maximising or minimising the depth of field.

A lens's focal length also has a direct effect on depth of field. A telephoto lens will have a much lower depth of field than a wide-angle lens. Depth of field is also greater if the lens is focused at a distance than when it is focused close up: this can be seen clearly in the shot, right. To maximise the depth of field you should therefore ensure that the subject is close to the background, use the wide-angle setting and take your pictures from a greater distance than normal. If this results in an unsatisfactory crop, then you can resample and crop the picture later on the computer.

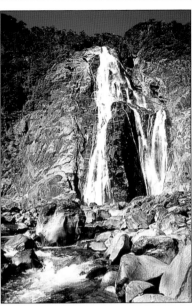

Left, the depth of field on this photograph of Bowen Falls in New Zealand means that the picture is sharp from the boulders in the foreground right to the top of the falls.

DIGITAL SOLUTION

You can artificially increase depth of field by selecting the background of an image on a computer and using the sharpen filter to make the image appear sharper - and therefore more 'in focus'.

47

Above, by placing the foreground and the background a long distance from the camera and using a telephoto lens, both will be in focus when the lens is set to infinity, giving effectively unlimited depth of field.

Related topics

50 - 53 Focal length
62 - 63 Selective focus

Selective focus ..

Selective focus is the opposite to maximising depth of field. You keep the depth of field so shallow that, although the main part of the picture is in focus, the rest is out of focus. This has the effect of making the main element stand out, for instance from a potentially distracting background.

If your digital camera has an adjustable aperture - presently uncommon on cheap and mid-priced models - then the best way to limit depth of field is to use the widest aperture possible. However, if your camera does not, then you can achieve the same effect by increasing the distance between the subject and the background, using a telephoto setting if possible and moving the camera closer to the subject. However, in digital photography, this is not a big issue: see under Digital solution, right.

You will have to focus the camera very carefully to make sure that the elements of the picture which you want to be in focus are sharp. If your camera has autofocus, direct the autofocus point at the subject and lightly depress the button to lock the focus. Next, compose the image without releasing the button and take the picture. Many digital cameras have a large preview screen which is useful for checking that you have the selective focus set correctly.

If the depth of field is still too great then it is possible to focus some distance in front of the subject. The depth of field will ensure the subject is sharp, but by moving the point of focus forward you will ensure that the background falls off the depth of field zone and will be soft.

Below, *limiting depth of field by focusing in close on the flowers in the foreground throws the background out of focus so that it is still discernable, and so sets the scene, but doesn't distract.*

Right, *a telephoto lens and a narrow aperture gives a very narrow plane of focus, concentrating the eye on the flames.*

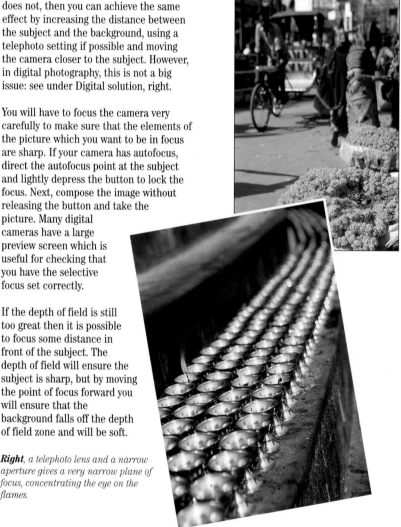

DIGITAL SOLUTION

Most image manipulation packages come with a range of blurring tools. By masking out the subject you will be able to apply the blur just to the background in order to throw it out of focus.

Related topics

50 - 53 Focal length
60 - 61 Depth of field

Below, focusing up close on a face can throw the background out of focus. Care has to be taken with focusing on reflections such as these mirror shades.

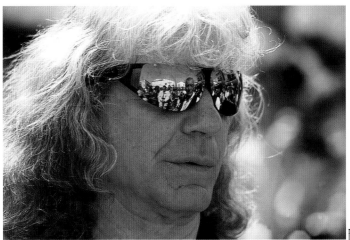

49

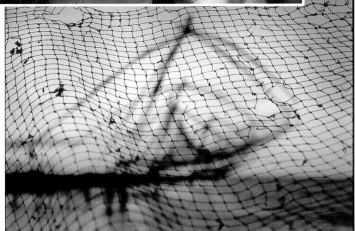

***Above**, selective focus can be used for a picture effect, such as with these Chinese fishing nets.*

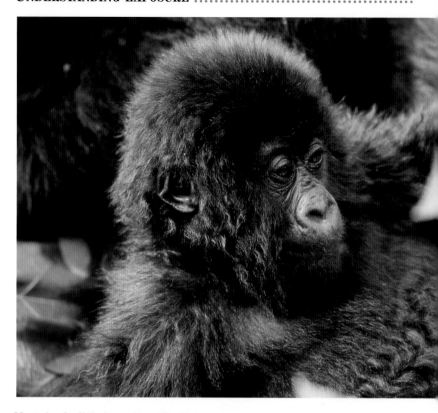

Most simple digital cameras offer little or no control over the exposure of your pictures, although this state of affairs is changing constantly. However, by understanding something about the way your camera calculates exposure, you will be able to get better results.

If your camera measures exposure, it does so by trying to quantify the amount of light falling on the subject. This means that if there are different light levels falling on different parts of the subject, the camera's light sensor will be confused. For instance, if your subject is standing in the shadows, and you want it to be correctly exposed as well as a brightly lit landscape behind, then there's a problem. The sensor is unable to measure such extreme differences in light level and the shadows will either be too dark, or the highlights too light.

There are two simple solutions: move the subject into the sunlight, or use fill-in flash (pages 60-61).

Another aspect of the problem is that your camera's sensor has no way of knowing whether the subject it is pointing at is white or an average mid-tone. Instead, it assumes that the subject is a mid-tone and calculates the exposure accordingly. Generally this works well, but if your subject is predominantly white, in very bright light the camera will assume that it is an average subject and will

Left, *the gorilla was deliberately underexposed to make the fur render as black, not washed-out grey.*
Below, *the Cuban's white shirt, and the pale background wall, would have fooled the meter into underexposing.*

underexpose. If your subject is predominantly black, then the sensor will assume that it is an average subject in very dull light and will overexpose.

If your digital camera doesn't offer the facility to override its automatic exposure system, then you can get around these problems to some extent by fooling it. Point it at a 'dummy' subject with average

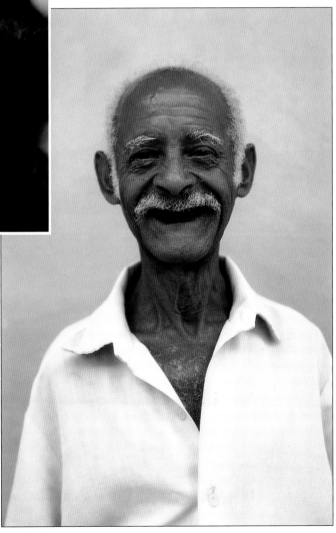

tones that is lit by the same intensity of light as your subject. Lightly press the exposure button and the sensor will take the light reading.

Then, while still holding down the button, compose and shoot your picture. The camera will 'remember' the exposure from the dummy subject and apply it to the real subject. One catch: if the camera has an autofocus system, it will focus on the dummy subject. So choose a dummy subject that is a similar distance from the camera as the real one. Review both exposure and focus on the preview screen to check that everything is OK.

With practice you will perfect this technique. Experiment with a straight shot as well as a corrected version so that you can compare. If your digital camera has no auto-exposure facility, then of course you don't have the option of fooling it; you can still correct the exposure on the computer later, but the quality will not be as high as if you obtained the correct exposure in the first place.

52

Right, the only way to correctly expose this shot was by moving in close to the body, so that light from the bright background was cut out and the camera's sensor could read from the subject. **Far right, top**, Getting the subject to move out of the heavy shadow in this Chinese street meant he was lit by the same light as the background. Pointing the camera's sensor at the wall gave the right exposure for the wall, and for the man's face. **Far right, centre**, photographing a white building through an arch can also confuse the camera's meter. Taking a reading instead from a medium-bright object in the same light as the Taj ensured that the exposure was right. **Far right, bottom**, the camel cart falls in a large shadow area - too big to expose correctly. Fill-in flash (pages 60-61) isn't a solution - on-camera flashes aren't powerful enough to light an area this size, and this far from the camera. The picture should not have been taken.

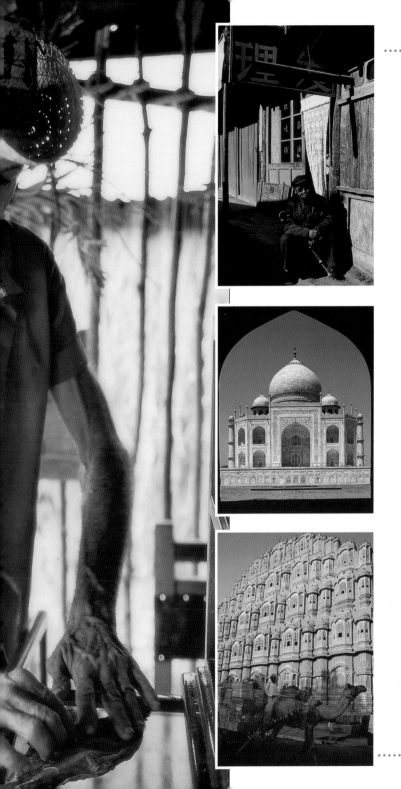

DELIBERATE UNDER- OR OVEREXPOSURE

Sometimes you will want to deliberately under- or overexpose an image - in other words, make it lighter or darker than normal.

*Left, correct exposure; **below** the image deliberately overexposed using digital software to create a high-key effect.*

If you underexpose, you make the colours appear darker and more saturated. The image will look more punchy and there will be a greater amount of detail in the highlight areas. There will also be a loss of detail in the shadow areas. This can be effective in, for example, a photograph of an old building where you want to emphasize the texture of mellow stonework.

Some subjects, such as portraits, can benefit from a degree of overexposure. A subtle amount can clean up skin tones and remove any blemishes; a large amount produces a dramatic 'high-key' effect when the highlights bleach out completely and the shadow areas register as mid tones. This is often used to create interesting portraits.

At present, digital cameras generally don't give much scope to create these effects - low to medium priced models give minimal control over exposure. You can, of course, make the exposure as normal and change the density of the image later by altering the density levels in an image manipulation programme; but the image quality will be greater if you can adjust the exposure change in the camera.

If a digital camera has automatic exposure control, you can sometimes fool it into over- or underexposing. See Understanding exposure, pages 50-53.

Left, slight underexposure produces improved colour saturation - an effect easily achieved on a computer during post-processing.

Related topics

50-53 Understanding exposure

55

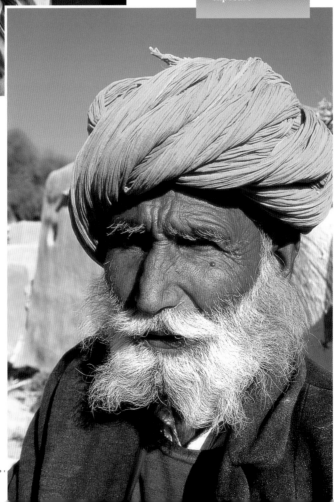

Right, a large degree of underexposure makes this a low-key shot, with plenty of detail in the beard that would otherwise have burnt out, and plenty of atmosphere.

FLASH

Light is the key to all photography, but there are times when there just isn't enough light to make an exposure. Many digital cameras come with a built-in flash, but these are generally very weak and will only be effective up to about six feet away from the subject.

If you try using a small on-camera flash to light a cityscape or a theatre production when you are sitting way back in the cheap seats, then you will be wasting your time. Most of these flashes are designed for photographing one or more people who are a few feet away. Check the instructions that come with your camera to see how far the flash will reach and stick to this distance.

Flashes provide very directional light. This means that they will only provide correct exposure at one point in front of the camera. If there is something between that point and the camera, it will bleach out; if there is something beyond, it will register far too dark. To get the best from a small on-camera flash, ensure that subjects are an equal distance from the camera, with no distracting bits in the foreground. The fall-off caused by small on-camera flashes can be used to your advantage. If the background is distracting, then leaving it underexposed - very dark in the final image - helps your subject to stand out from it. This can be seen in the photograph of the Zimbabwean dancer where the background has virtually turned black.

Below, dancer in Zimbabwe stands out from a dark background because of the use of a flash.

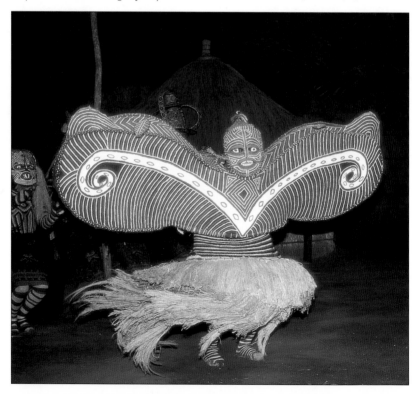

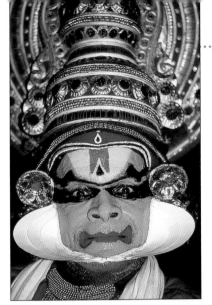

Related topics

58-59 Slow synch flash
60-61 Fill in flash

Left, portraits taken with direct flash are very contrasty and the lighting is very harsh; but this is not such a problem with subjects wearing heavy make-up, such as this Indian dancer.

Below, flash is useful for freezing action, as with these Shanghai acrobats, but if using on-camera flash, to get this shot you would have to sit near the front, as the flash isn't very powerful.

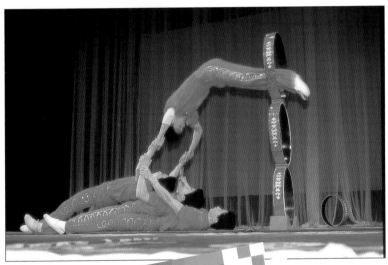

57

Professional tip

In order to soften flash light for portraits, many professionals fix a piece of white tissue paper in front of the flash. Check that this doesn't obstruct any sensors that the camera uses to calculate exposure, and be aware that as well as softening the light it will effectively make your flash less powerful.

SLOW-SYNCH FLASH ..

Many of the built-in flashes on simple digital cameras have the ability to mix flash and available light. In certain situations, when the light level is low, such as in a night club, the camera will set a slow shutter speed and match the flash with it. This has the useful result of the background being blurred - whether by subject movement or by camera shake - and the subject being picked out sharply by the flash.

Below, *an Indian dancer making up. Slow shutter speed has allowed both movement and a colour cast whereas the flash has frozen the movement.*

Related topics

56 - 57 Flash
94 - 95 Panning

Sometimes, when the subject is moving, it will show a mix of blur and sharpness which accentuates the feeling of movement at the same time as giving some sharp detail on the subject. Again, this can be an interesting creative effect.

A refinement to slow-synch flash, found currently on the most advanced digital cameras (but commonly on good quality conventional compact cameras), is the facility to fire the flash at the end of the exposure, rather than at the beginning. Firing at the beginning means that the blur will run through the subject; whereas firing it at the end makes the flash-lit image overrides to blur, producing a much more pleasing result.

A similar result can be produced by

Above, slow-synch flash has not frozen the movement.

panning the camera during the exposure to cause the whole scene to blur, except the subject in the foreground, which is picked out by the flash.

Slow-synch flash can be a hit-and-miss affair, but with some experimentation it is possible to produce worthwhile results - and to develop a feel for what the subject in front of the camera will look like in the final image.

FILL-IN FLASH/REFLECTORS ··

A digital camera - or a conventional camera - with some kind of automated exposure facility should be able to work out an accurate exposure for most situations, but there are times when it can underexpose a subject so much that the image is spoilt.

If your subject is standing in front of a bright window, or is in shadow in front of a brightly lit background, then the camera's exposure sensor will calculate the exposure for the area behind the subject. The sensor is dominated by the large, brightly lit area, which will be correctly exposed while the subject will turn out under-exposed - as a dark silhouette. To avoid this, simply switch on the flash. The camera will still calculate the exposure for the background, but the flash will light the subject in the foreground, bringing its exposure into line with the background's. As long as the subject is within the effective range of your camera's flash, then the whole picture will be correctly exposed.

This technique is also useful for portraits. The ideal times for taking portraits are early in the morning or late in the afternoon when the light is not directly overhead and will produce a more flattering light. Sometimes, however, you will have to take photographs when the sun is overhead. To avoid deep shadows on the face, use fill-in flash.

Below, deep shadows in the face caused by midday sun.
***Right,** the shadows eliminated by fill-in flash.*

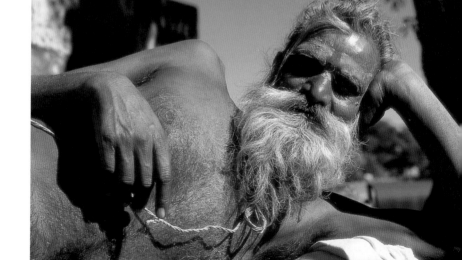

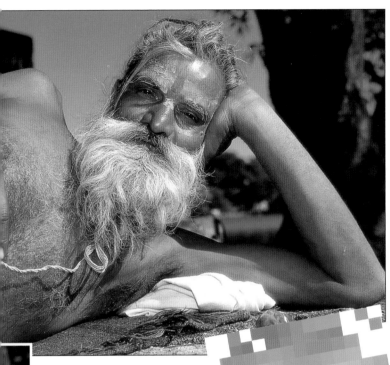

Related topics

50 - 53 Understanding exposure
56 - 57 Flash

Professional tip
Many professional photographers carry fold-out reflectors to give a more controllable and natural looking light than a flash.

Below, *without fill-in flash, with a reflector and finally with fill-in flash.*

Different wavelengths of light have different colours. We don't 'see' them because the eye, a remarkably sophisticated optical instrument, automatically corrects the colour balance. A camera, however, is not so clever, and sees light as it really is.

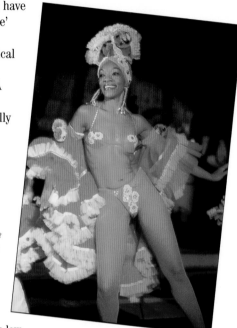

Right, a warm colour cast adds to the atmosphere of this image of a Cuban dancer

62

Without correction, light with a low wavelength, such as tungsten light bulbs and candle light, will register on light-sensitive media as yellowish. Light with a high wavelength, for instance daylight from a blue sky, comes out blue.

Low and medium-price digital cameras are calibrated for average daylight, which will register as white. More sophisticated models generally have an automatic white balance that adjusts the colour to compensate for the wavelength or colour temperature of the light. Some cameras allow you to set manually whether you are shooting indoors or out of doors. This is useful because it allows you to correct the colour balance when you want to, but to keep colour cast if it helps to convey atmosphere or something special

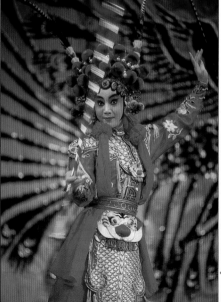

Left, shooting a picture under artificial light without correction will give an orange-yellow colour cast.

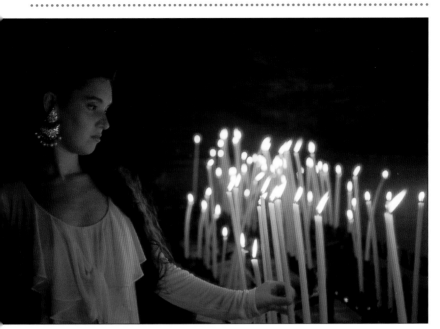

about the subject.

Sometimes, as in the examples on these pages, a warm colour cast from an artificial light source can improve a picture. To achieve this effect, simply leave the camera set on the outdoor/daylight mode and shoot in artificial light. Shooting outdoors with the indoor/artificial light setting will, by contrast, give a blue cast to your pictures.

Above, the warm glow from candle light improves this picture of a pilgrim lighting a candle in a church in France, whereas the same shot taken with the corrected light of flash looks very harsh and unatmospheric.

63

DIGITAL SOLUTION

Colour casts from artificial light can be removed on a computer during post-processing, but you will generally get better results if you correct in the camera, since this preserves more of the image information.

Related topics

64 - 65 Sunsets and
colour temperature

Left, the colour temperature of a sunrise giving a golden-orange colour cast.

Uncorrected tungsten light can show up as orange in a photograph - and so can morning and evening light. See Colour temperature, pages 62-65. The orange colour of a sunset is caused by a reduction of light in the blue wavelength. (The human eye automatically adjusts for this - so in a sense, we never see the full glory of sunsets.)

There are number of ways to approach sunsets. The conventional view of the sun setting over the sea may look OK in your viewfinder, but unless you have a very powerful telephoto lens, then the sun itself won't show up much bigger than a pin prick. You"ll get a better result photographing the sunset reflected in a slightly cloudy sky, where the whole sky will glow orange, pink or even dark red.

Above,
the warm glow of sunset light,
excellent for portraits.

Placing a silhouetted object - even a corny one such as a palm tree - in the foreground almost always gives a sunset picture extra depth - and may act as a reminder in later years of where it was taken.

Sunsets change rapidly, so keep making exposures. Sometimes they get better and better; sometimes they just fizzle out and

the colours fade disappointingly. With a digital camera you have the luxury of making continual exposures and then looking at them at your leisure on the screen, deleting the ones you don't want.

Don't forget sunrises. The colours are more subtle than at sunset and if you are

Right, an example of how warm the light of sunset renders in a photograph, compared with what the human eye sees.

near water you will get an interesting, misty effect such as in the shot shown here, taken in China.

65

Photographing people or objects lit by sunset or sunrise will give them a warm, golden glow, especially flattering for portraits. This light is only around for a few minutes, so be ready.

Any digital imaging software will allow you to improve the colour intensity and balance of a sunset or a sunrise.

Left, a foreground object silhouetted against a sunset adds useful depth.

Composition

Most of the traditional rules of photographic composition are valid for digital photography and digital imaging. Often enough, photographers follow these rules without thinking. After all, they are based on what the eye finds most comfortable to see. On the other hand, it's well worth trying to put them into practice because conscious effort will increase your success rate. So here's a brief refresher course:

1 The thirds rule. A picture almost always looks best if its subject is biassed to the top or the bottom of the frame, rather than stuck in the middle.

If there's a horizon in the picture, then it should fall a third of the distance either from the top or from the bottom of the frame. If it's a portrait, then the eyes will look much more balanced if they fall on a line marking the top third of the picture.

Left, *New Zealand sheep.*

Right, *looking into the other two thirds.*

Left, *horizon obeying the thirds rule.*

2 Not just horizons. All sorts of subjects can be improved by the thirds rule - one example being the photograph of the sheep in New Zealand. This picture also illustrates two other interesting rules of composition: using a **diagonal line** to lead the eye to the subject and **balancing the frame** by having a subject in one third of the picture looking into the other two thirds.

Moving objects can also benefit from this treatment. It is much the best to have space in the frame into which the subject can move: it gives a sense of balance.

3 When photographing landscapes, **keep the horizon straight**. If you tilt one end of the camera, the picture will look strange. This is especially true of seascapes.

4 Beware of cropping a portrait just below a joint such as a knee or an elbow: it can look odd. Rather than crop just below the knee, crop just above it.

5 Check that your shot isn't spoilt by the perennial problem of **trees and poles** sprouting from people's heads. By moving your viewpoint slightly, it's often easy to eliminate them. True, you can remove them later on the computer, but there are more interesting ways to spend your time with digital imaging software.

Left, shooting through an arch is an aid to composition - it concentrates interest on the subject. Below, leaving room in the frame for the subject to 'move into'.

6 A distant view almost always looks more balanced if you include some item in the foreground. This is especially true of hazy mountain scenes, in which a foreground object helps the eye to comprehend the scale of the background.

Remember though, that the most important thing about photography is taking photographs. Don't be such a slave to composition that you let the moment pass you by. With a filmless digital camera, the name of the game is shooting plenty, ignoring film and processing costs, and staying relaxed because you know you can patch up minor defects later on the computer. Then, poring at leisure over the shots on the screen, ask yourself why particular shots do or don't work, and work out some composition rules of your own.

69

CROPPING IN THE VIEWFINDER ·····························

When it comes to cropping, digital photography offers great flexibility compared with conventional photography. Instead of having to get it right in the viewfinder, you can crop with ease, and at your leisure, on the computer screen. This is a major creative bonus because, of course, cropping is one of the keys to good composition.

Above, *turning the camera on to its side and zooming in to crop out the baby elephant in the foreground would have improved this shot.* **Left**, *cropping in tight as shown by the dotted lines would remove useless information and concentrate attention on the subject.* **Right**, *cropping in close as shown would emphasize the symmetry of these zebras seen from behind.*

DIGITAL SOLUTION

Cropping on the computer is usually worth doing - and very much part of the fun of digital photography. Remember that you can reduce loss of quality caused by cropping (see above) by resampling and sharpening the image. See pages 106-107 for more details.

However, there is one drawback to cropping on a computer. In doing so, you effectively throw away information from the picture.

Take out a large area, and the digital information which is left has to be enlarged in order to make up for what has been discarded. That means a coarser quality to the final printed image.

So while small crops on the computer are insignificant; large crops are best made in the viewfinder. As a rough rule of thumb, ask yourself, before making an exposure, whether there are any unwanted elements in the picture. If so, edit them out by moving in closer, or by zooming in on the main image. Leave fine-tuning for the computer.

71

Simple optical viewfinders are not particularly accurate at showing the full image recorded on the light-sensitive medium. So if your camera has an LCD preview screen - which is accurate - be sure to make use of it. By mounting the camera on a tripod and using the LCD screen, you will find that you can make very fine changes.

Related topics

66 - 69 Composition
106 - 107 Sharpening
110 - 111 Resolution

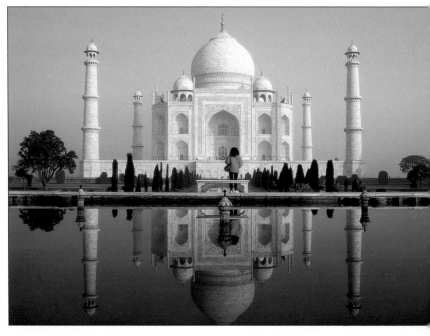

Above, use of simple colour contrast.

We are so used to seeing in colour that very few photographers actually think about what it takes to make a good colour photograph.

In most subjects the colours, some muted, some bright, are mixed up randomly in the frame. What sets a good colour photograph apart from what is merely a good photograph which happens to be in colour is the way that those colours work together.

The simplest way to use colours well is to select a subject whose colour contrasts in some way with the colours in the background. Take the photograph of the Taj Mahal. The eye is instantly drawn to the tourist in the bright red coat. She dominates the frame, even though she is small. The red glows nicely against the background of neutral white and muted blue.

Another well-known ploy is to use all bright primary colours. This is shown by the photograph in which the Cuban flag effectively dominates the colour scheme. The colour effect is also accentuated by the lighting.

In complete contrast, you can sometimes get a great picture with a very limited 'palette' of colours, producing a colour image in name only, but with low contrast and a muted effect more typical of black-and-white photography.

DIGITAL SOLUTION

You can alter both individual colours and the entire colour palette in most digital imaging software. The best way to learn is to experiment.

Above, a very limited colour palette in this photo of a schooner at Jakarta, Java; ***below,*** the dominant effect of bright, primary colours in combination.

73

BLACK-AND-WHITE ..

Black-and-white photography has long been held in high regard by photographers as a purer form than colour. With the arrival of cheap colour processing, black and white photography has become a more and more marginal activity - but it is still a very creative option. Digital photography has turned this state of affairs right round again. Turning a colour image into a black-and-white one is simple, and creatively very interesting, at the post -processing stage in your computer. You simply discard the colour information - most digital imaging software packages make this an easy option. The initial result may look too grey, but you can restore the punchy blacks which are often associated with black-and-white photography by using other controls offered by the software to adjust brightness and contrast.

One of the most difficult aspects of black-and-white photography is visualising what the subject will look like once it has been reduced to a series of greys. Experience will help you to work out which subjects will produce good black-and-white images, but there's an old trick that can help, too. Fit a yellow filter over the viewfinder. This reduces the scene to a monochrome (albeit yellow-tinted) view which will approximate to the finished image. Any piece of transparent material, even a sweet wrapper, will do for this purpose.

Once you have produced a black-and-white image in your

computer, it is also possible to tone it, giving it a slightly tinted appearance which emulates high-quality black-and-white printing paper. Your image manipulation software may also have settings for both warm and cold duotones which can further add atmosphere and substance to your pictures.

Left, *converting this shot to black and white eliminated the distracting effect of the ugly yellow-green concrete that the bear is sitting on.*
Above, *converting to black-and-white usually works well when a picture has a wide range of tones, from white, through an assortment of greys, to blacks.*
Right, *large areas of shadow such as in this doorway can be effective in black-and-white because black sets off detail in the highlights and midtones, such as the man's hair and face.*

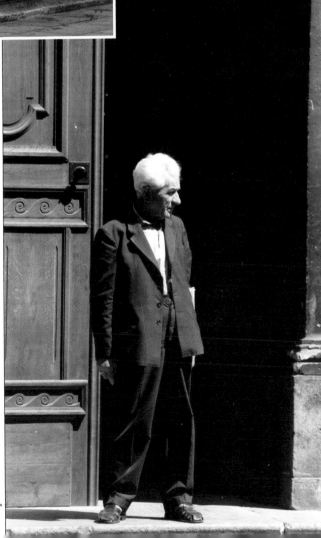

75

FILTERS

Filters are basically bits of optical glass or resin which fit over the lens, and affect the properties of the light which passes through it. They fall broadly into two categories - those used for enhancements to the image and those used to create special effects.

Right, the effect of a polarizing filter can be seen from this photograph of a mountain in New Zealand, where the sky has been darkened and the haze reduced.

76

Currently, many digital cameras don't have the ability to take filters which fit on to the lens, but even in this case it is possible to get filter effects by holding a filter in front of the lens.

The human eye is much better at handling contrast than the sensor in your camera. Skies which appear to render perfectly to the human eye can bleach out in the final image. A graduated neutral density filter will darken the sky without colouring it. There is a full range of coloured graduated filters available if you want to add colours to the sky as well. A polarizing filter is one which cuts out polarized light, which is made when light reflects off things at certain angles - such as off shiny objects and on water droplets in the sky on a hazy day. If you use a polarizing filter you can cut down reflections and glare in your pictures and darken blue skies - greatly improving landscapes, especially mountain scenes where there is normally a good deal of haze.

Related topics

62 - 63 Indoor lighting

Other filters exist for novelty special effects such as starbursts, fog or multiple images on the same frame, but these effects are often best carried out on the computer.

Left, a novelty multiple image filter has been used in this portrait of Simba the Cat to make the picture more interesting.

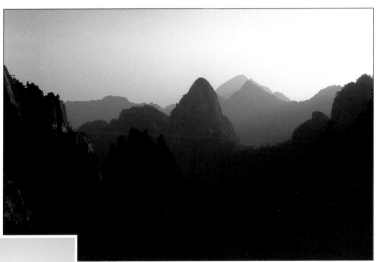

77

Above and left, *a graduated tobacco filter has been used to colour and darken the sky in this shot of the Huangshan Mountains in China.*

DIGITAL SOLUTION

Many of the effects of filters can be replicated on a computer using image manipulation software.

PORTRAITS AND GROUPS

One of the great strengths of the digital camera - provided it has a preview screen, as most now do - comes out when you take a portrait or a group. The screen means you can check, after making the exposure, whether everyone was looking at the camera, and whether there's been any unwanted movement, typically from talking or blinking. Not only this, but you can delete the unwanted shots, time after time, until you get the right one - so saving space in the camera. And of course, digital imaging software also allows you to remove red-eye, and to retouch facial blemishes at a later stage on the computer. See pages 134 - 135.

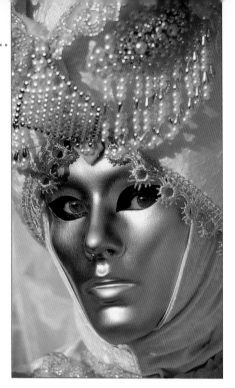

That said, the key to successful portrait photography is the same whatever type of camera you use: it's all about interaction. You have to put your subject at ease, and to do that, you have to talk to them, even encourage them to play up to the camera.

Eye contact is essential - eyes are the windows of the soul and anyone looking at one of your portrait photographs should benefit from the unique opportunity a photo provides of looking into someone's eyes at length, rather than for the short periods normally allowed by social situations.

Many people find it difficult to ask a stranger if they may take their photograph, but it is the right thing to do, both from a photographic and a moral point of view. Sometimes 'stealing' a photo can lead to problems.

The best lens for portraiture is a mild telephoto, with a 35mm-equivalent focal length of between 80mm and 140mm. A

Above, a portrait with several original and arresting elements - but the eyes are still the making of the image.

Right, another fixed lens portrait, taken well back from the subject - in fact, camel and rider were even smaller in the original image. The image was later enlarged a little on screen and the crop adjusted at leisure to get the composition just right.

digital camera with a zoom lens will give you a choice of focal lengths between, say, 35 up to 105 mm, so the longer settings, between 80 and 105mm-equivalent, will be ideal, giving a pleasant perspective on the face. However, if your digital camera has a fixed focal length lens, don't be put off. Although the fixed focal length will probably be the equivalent of a 35mm wide-angle, you can minimize its unflattering tendency by accepting that you won't be able to get close in on the face, and instead compose your picture so that the subject is placed in an interesting relationship with the background. See the examples on these two pages.

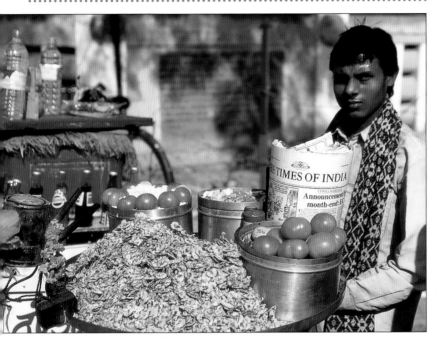

Above, portrait taken on a low-cost digital camera with a fixed focal length lens, staying about 6 feet away in order to minimize distortion. Not getting in close to the vendor's face hardly matters - in fact the picture works well because he's seen in relation to his wares.

Related topics 79

42 - 45 Focal length

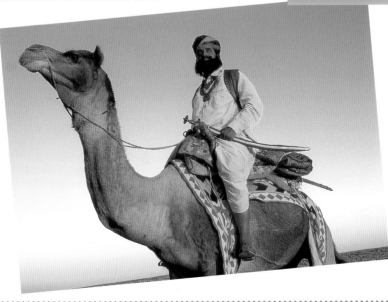

LANDSCAPES

If your landscape image is captured digitally, you're ahead of the game in as much as removing unwanted and distracting elements is simple on a computer: see Digital Solution. Otherwise, the principles of this often challenging field are very much the same as in conventional photography.

Above, Bali rice paddies - see the main text on this page.

DIGITAL SOLUTION

There are actually relatively few perfect landscapes in this world. The proliferation of buildings, electricity pylons, roads and telegraph poles spoils many otherwise perfect views. So digital photography comes into its own when removing unwanted elements from landscape shots on the computer.

Landscapes change dramatically as the light changes. Successful landscape photography is not just about finding the right spot or composition, but waiting for the right time to take your pictures - and this can be hours, even days. No matter how superb the panorama laid out in front of you, if you take the picture in the harsh midday sun, it will look awful. Midday sun comes from directly above, and gives very harsh, featureless light. In the early morning, or late afternoon, the scene will be bathed in warm light which will give interesting shadows and pick out details.

It is also important to wait not just for the right time of day, but for the right day. For instance, the rice paddies of Bali look best when photographed with the early or late light backlighting them, but if there is a grey, overcast sky this won't happen.

Above, essential foreground detail.

You can add much interest to landscape shots by including some kind of detail in the foreground - perhaps a gnarled tree trunk or weird rock formation - that says something about the landscape as a whole.

And don't forget the sky. An interesting cloud formation can make a picture, just as the vapour trail from an plane can ruin it. Clouds change quickly and so you must be ready at any time to take the picture. In fact, you must stay alert at all times in case the light suddenly does something special.

81

*Above, harsh, featureless midday light; **right,** soft evening light highlighting essential texture.*

Related topics

PHOTOGRAPHING BUILDINGS

Perhaps the commonest fault of architectural photographs taken on conventional cameras is converging parallels. This usually happens when a building is too tall to fit into the frame: you tilt the camera to get the top in, but because the top of the building is so much further away from the camera lens than the bottom, it appears smaller, or narrower. This effect is most noticeable when using a wide-angle lens, whose design inherently distorts straight lines. Another common fault is unwanted foreground (or background) detail such as cars or telegraph wires.

One of the biggest bonuses of digital imaging is that it makes light of these traditional banes. They are easy to solve using most digital imaging software, provided you are prepared to take a little trouble. People in the business of buying and selling houses are finding this has revolutionized the production of sales information sheets.

That said, there's no harm in trying to minimize converging parallels when actually shooting. The simplest solution is not to tilt the camera. Try to find an angle from which you can point the camera face-on to the building. This may give you more of the foreground than fits the composition, but digital imaging software allows you to crop this out later. You can also reduce the narrowing effect by using the telephoto setting of your zoom: but that will mean standing further away. People often think of architectural photography in an unnecessarily straightforward way. So much more can be conveyed in an architectural shot just by choosing a different angle or going in close and focusing on a portion. Look, for

82 *Below, a straight shot of the Taj Mahal. Not tilting the camera has eliminated converging parallels with the minarets - but in any case they lean outwards as a precaution against earthquakes.*

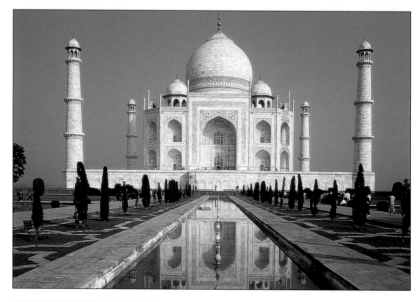

instance, at the photograph of the Taj Mahal, above, taken through reeds. This actually shows the back of the monument and you don't see much detail. But you do get a feeling of mystery, mood and location - far more than in the more conventional image.

Above, a different view of the Taj, taken from the back, through reeds.

83

Below, using a telephoto setting on a zoom compresses perspective, making the monument appear to loom in the frame.

Related topics

42 - 45 Focal length
66 - 69 Composition

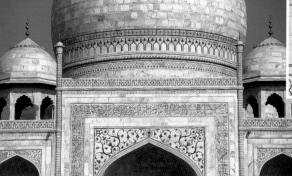

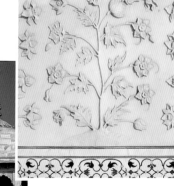

Above, going up close and focusing on a detail is another way of showing the beauty of the whole building.

...

Left, close-ups are often ideal candidates for extreme image manipulation due to their graphic or abstract nature. Here, a rather blurry close-up of an eye, has been 'rescued' in Photoshop.

Below, the world of nature really opens up once you 'move closer'. You will find your garden contains a hoard of suitable subjects. Try and shoot in good light to avoid camera-shake.

84

Move closer

One area in which most digital cameras excel is close-up or macro photography. No budding digital artist can afford to ignore the fascinating and rewarding results that can be got by simply moving closer to even the most mundane subjects. In fact, one of the beauties of macro photography is that there is a whole world of potential subjects right under your nose: in the house, the garden and even in the refrigerator. You need never again be stuck indoors on rainy winter days with nothing to photograph. And since your digital camera will never run out of film, you can afford to experiment, and perhaps, create some truly stunning images using your camera's macro capabilities.

Close-up shots work especially well in photomontage compositions, and also

Above, don't be afraid to get even closer to flowers to show some of the fascinating inner details.

naturally lend themselves to more abstract works where the true nature of the original subject is hidden completely. On a more prosaic level, close-ups are an essential part of many business and consumer uses of digital cameras, bought for the photographing of fine details for recording/cataloguing purposes.

...

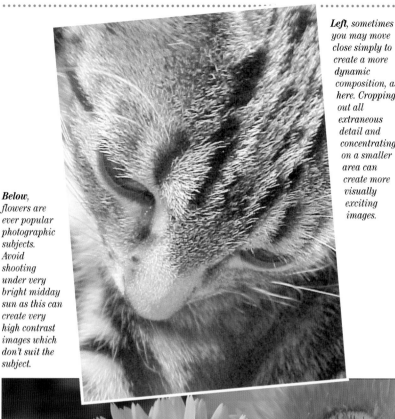

Left, sometimes you may move close simply to create a more dynamic composition, as here. Cropping out all extraneous detail and concentrating on a smaller area can create more visually exciting images.

Below, flowers are ever popular photographic subjects. Avoid shooting under very bright midday sun as this can create very high contrast images which don't suit the subject.

85

Tips for close-ups

There are a few technical points worth considering before you embark on a series of close-up photographs. Accurate focus is essential: if your camera has a macro function, use it, as this allows the lens to focus closer than usual. Check in the manual the closest the lens can focus and don't try and get any closer as everything will blur. With close-ups there is a very limited depth of field (see pages 46-47) which means the slightest focusing inaccuracy will result in images that are totally out of focus. Use the LCD preview monitor; at very close focus there is a huge difference between what the CCD sees and what you see through the optical viewfinder. Avoid the use of flash: few cameras' automatic flash systems work at short distances, often resulting in grossly overexposed (washed out) images. Disable the flash (and use a household standard lamp if you need more illumination). Finally, it is often a good idea to use a tripod: the narrow depth of field and the danger of camera shake (which is much greater with close-ups) mean that proper rigid support for the camera can mean the difference between a stunning close-up and a blurred mess.

Above, close-ups are often essential when photographing for record keeping or cataloguing. Remember to keep lighting as flat as possible to capture the maximum information

Photographing for record-keeping

Whether you are a stamp collector or a silverware auctioneer, you may well have need to catalogue photos of small objects in the course of your work or hobby. Whilst all the rules described here still apply, bear in mind that you are trying to record as much information as possible in the photograph. To this end it is advisable to create a standard shooting set-up (with fixed lighting and camera position) which is used every time. For flat objects such as stamps you will want lighting as flat as possible – for this purpose daylight from a window is ideal, but artificial lighting is more controllable. For very flat lighting you can construct a cone of paper that fits over the subject and is lit with a couple of external lamps. The camera is then pointed through the thin end of the cone. Objects with some depth often need more directional lighting (one lamp to one side), as this emphasises relief.

Accessory lenses

If you are lucky enough to have a digital camera with an accessory lens thread, then you can extend its macro facilities dramatically using close-up filters. These

inexpensive add-ons can be bought in
various strengths and act much like a
magnifying glass in front of the camera.
Not all cameras have lens threads, but
there are plenty of 'bolt-on' solutions that
allow the use of close-up lenses on
'threadless' cameras.

87

Above and *below*, close-ups need just as
much attention paid to their composition.
Try isolating parts of everyday objects or
shooting from an unusual angle. You'll be
surprised at the fascinating semi-abstract
images you can create without ever leaving
the house.

Above, getting even closer (by using
specialist equipment) allows you to
disguise the true nature of your
subject and create truly abstract
images, as this extreme close-up of a
vinyl record shows.

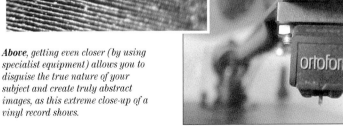

Night photography

Digital cameras that offer some degree of exposure control offer the chance to get interesting results from night photography, provided you follow the advice below. Very simple ones, with no exposure control, limit your options just as conventional cameras do.

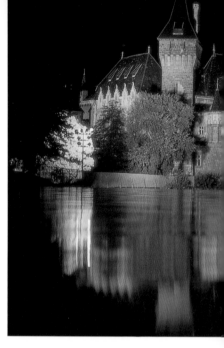

All the shots were taken on digital cameras with a modest degree of exposure control, using the tips on these pages.

The first rule is to use a tripod or a beanbag: slow shutter speeds make it impossible to keep a hand-held camera steady enough for good results, even with the option of sharpening the picture later on the computer.

The second golden rule is to take your photographs not at night but in the evening. The best time is dusk: photographs almost always look much better if there is some detail in the sky. The colour temperature (see pages 64-65) of the sky at dusk renders the sky in deep, striking blues, purples or pinks - even without a sunset.

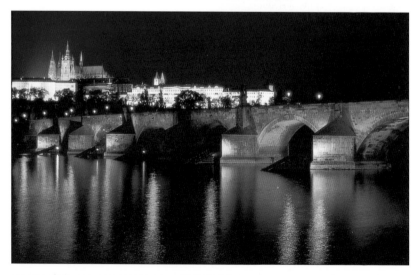

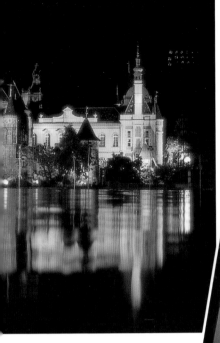

89

Colour in a sky at dusk will also go some way towards balancing the brightness of a floodlit building. (The eye automatically corrects this imbalance - but a camera won't.) A flood-lit building against a fairly dark sky will render as a white blob against a black background in your picture, even though through the viewfinder it seemed like a striking shot with a dark purple sky.

Reflections are very useful for filling up otherwise dark spaces in a night-time shot.

Look for reflections in lakes, fountains or even puddles on a street. Even in the worst weather, it is possible to get good night photographs - and by reflecting your subject in a puddle you can double the amount of light in the frame.

Technical tip:
The flash on your digital camera won't be powerful enough to light the subject in front of you, but if the camera has exposure control, you can force it to make a longer exposure by switching off the flash.

Above left, catching the vaulter at the apex of his jump meant it could be frozen by a relatively slow shutter speed. *Above right*, bright light allowed a very fast shutter speed to freeze the water as this Sadhu bathed in the Ganges - the type of shot that's currently impossible on most consumer digital cameras.

FREEZING ACTION

Photography has the unique ability to freeze moment, preserving a slice of time. It's a shame that variable shutter speeds are, as this book goes to press, a feature only of expensive digital cameras; but in due course, variable shutter will be available on cheaper models.

To freeze action, you have to choose as fast a shutter speed as possible; if the camera doesn't allow you to select, then it may be possible to force it automatically to select a fast shutter speed by shooting in the brightest available light.

In most movement, there is usually an instant - for example a pole vaulter clearing the bar - when the action is at its peak and sums it all up. This almost always makes the best photograph. To catch it, press the shutter just before the peak is reached to allow for the usual time lapse of shutter operation.

Some digital cameras can capture a burst of images in a short time. This means you have several chances to capture that 'perfect' exposure - or to get an interesting sequence of the action building up and subsiding.

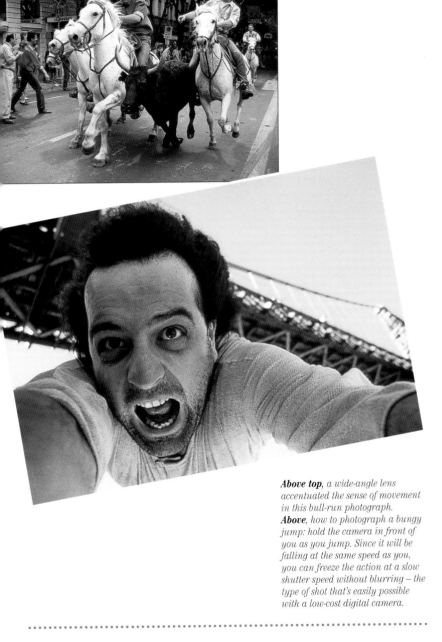

Above top, *a wide-angle lens accentuated the sense of movement in this bull-run photograph.*
Above, *how to photograph a bungy jump: hold the camera in front of you as you jump. Since it will be falling at the same speed as you, you can freeze the action at a slow shutter speed without blurring – the type of shot that's easily possible with a low-cost digital camera.*

BLURRING

Blurring occurs when either your subject (or your camera) moves during exposure: the movement is recorded on the light-sensitive medium - digital memory or film. Blur can be a problem in your photographs, but it can also be used as a creative tool to emphasize movement. If you have a sophisticated digital camera, with adjustable settings for exposure, then you need to set the slowest shutter speed possible to get the maximum blur. The longer the shutter is open, the further the subject can move during the exposure and the greater the blurring effect.

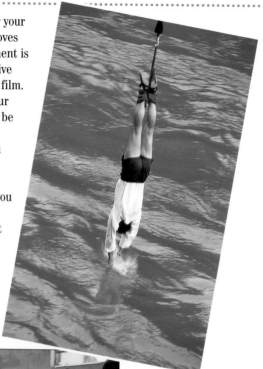

Above, selecting a very fast shutter speed freezes the whole picture.

Left, partial blur: the hand of the stone carver shows some movement - a useful graphic device, making clear the nature of the worker's action.

Left, partial blur: much of the subject is still, with only the bull and the cape having moved and showing blur. Again, this is a useful device, emphasizing the matador's poise in contrast to what is happening around him.

Right, digitally introduced blur, using PhotoSuite II. See also pages 138-141.

93

At present, most digital cameras do not have an adjustable shutter, but you can maximize blur by positioning yourself perpendicularly to the direction of movement or by using the telephoto setting on your zoom lens if your camera has one. Both of these options will greatly emphasize any movement in the image. You will have to choose a subject which is moving quite fast - typically running speed or quicker - in order to ensure that there is enough blur. You should always make sure that the effect is pronounced - that way everybody will know that you intended there to be blur in the picture - and it wasn't an accident.

It is unnecessary to try to blur a whole subject. Pictures can work well if only part of the subject is blurred, such as the photograph of the Zimbabwean stone carver where only the hand is blurred.

DIGITAL SOLUTION

Blur can be introduced into your images at the post-processing stage on your computer using a plug-in filter. This allows a greater degree of control than when using a camera, but may not look as natural.

Related topics

58 - 59 Slow synch flash
94 - 95 Panning

PANNING

To pan, you move the camera at the same speed as the subject. The subject remains relatively sharp, but the background blurs, giving the impression of motion.

Panning works by keeping the subject in the same place relative to the frame; the background is effectively smeared across the image. This technique is often used by professional photographers as it conveys a great sense of movement but ensures that there is enough detail in the subject for it to be recognizable.

Not all subjects are suitable for panning. The best subjects are those where the movement is steady and perpendicular to the photographer. It takes a good deal of practice to get the right amount of camera movement. If your digital camera allows you to select shutter speeds, you should select as slow a speed as possible. Most digital cameras, however, lack this facility. Your best option is to stand perpendicularly to the subject and to use the telephoto setting of your zoom lens. Follow the movement of the subject by smoothly matching its speed: try to keep it in the same place within the frame. Squeeze the button as the camera moves and keep it moving even after you think the shutter has closed. This helps to keep the panning action smooth. If you are photographing a subject which is moving perpendicularly to you, then using the telephoto setting of your zoom will accentuate the impression of movement (as mentioned above), and allow you to crop in tightly.

Above, panning when movement is perpendicular to the camera and using a telephoto setting causes maximum background blur.

It is possible to pan with a subject which is passing at an angle. Selecting a wide-angle zoom setting and getting in close to the subject will also distort the subject as you pan. See the photograph at the foot of this page.

Below, *using a wide angle lens setting when the subject is passing at an angle distorts the subject as well as blurring the background, giving a great sense of movement.*

Related topics

58 -59 Slow synch flash
92 - 93 Blurring your pictures

95

SHOOTING A PHOTO STORY

Many photographers only think in terms of a single photographic image, but often a series of pictures will have a unique impact. And with digitally captured images, you have maximum potential to develop this impact at your leisure by means of the control over cropping and image size offered by digital imaging software. You will find this topic especially relevant if you want to introduce digital images into a brochure or newsletter, or indeed a website.

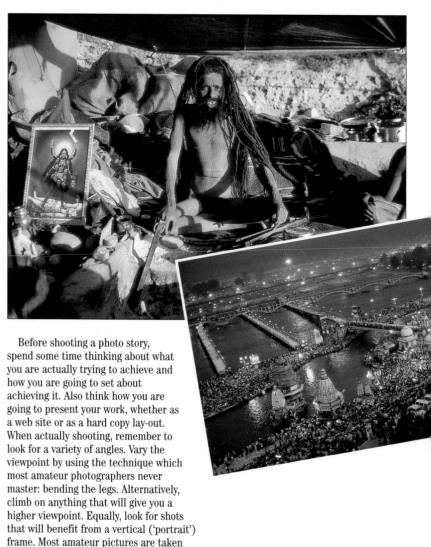

Before shooting a photo story, spend some time thinking about what you are actually trying to achieve and how you are going to set about achieving it. Also think how you are going to present your work, whether as a web site or as a hard copy lay-out. When actually shooting, remember to look for a variety of angles. Vary the viewpoint by using the technique which most amateur photographers never master: bending the legs. Alternatively, climb on anything that will give you a higher viewpoint. Equally, look for shots that will benefit from a vertical ('portrait') frame. Most amateur pictures are taken horizontally ('landscape format'); and a few portrait images will provide some essential variation in the shapes that you

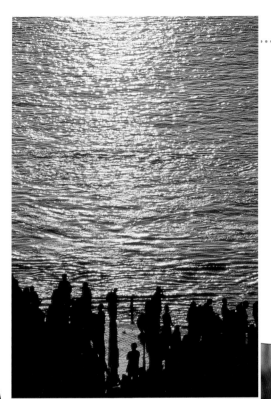

can play with to create a
satisfying layout.

Shoot around the subject.
Don't just go for the obvious
images. Focus on details and
on peripheral events, and, if
relevant, try to get close-up
portraits of participants and
bystanders. Always try to
come away with an overall
view of the action: it will be
very useful in setting the
scene for your lay-out.

Lastly, remember that
although your pictures, will
be viewed together, each
picture must be able to stand
out on its own. A photo story
is not an excuse to present
sub-standard work.

97

Related topic

168 - 169 Web site

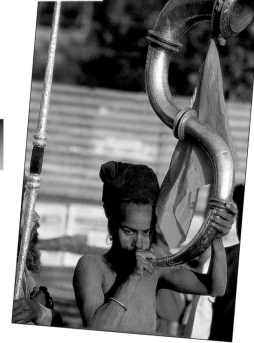

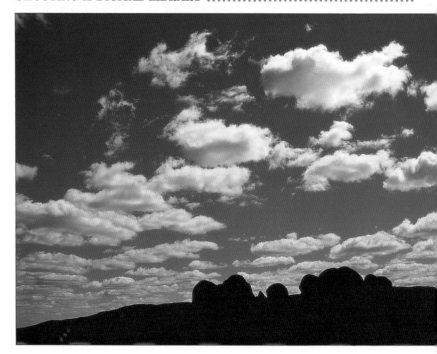

Above, great sky, useless foreground - so store it for future use.

Among the most interesting possibilities of digital photography is combining images on a computer either to improve an existing shot - say by replacing a dull sky with a striking one - or to create an entirely new composite image by montaging several shots together.

Newcomers to digital photography find that making composite images is surprisingly time-consuming. For success - and satisfaction - all the elements have to be just right. Inevitably, you find that you're missing one key element, or that one is sub-standard.

Fortunately, the ease of storage and reusability of digitally-captured images means that you can photograph interesting elements or people and store them for future use. All sorts of images are useful: fluffy white clouds in a blue sky, waves breaking, telephone boxes, notable faces, idyllic settings.

When photographing images for storage, take the subject from a number of different angles and viewpoints so that the perspective varies. This helps to ensure that there will be an image with the right perspective for any future use.

Related topics

Right, *weird sculptural postbox, spotted on a trip to New Zealand, and preserved for a digital library.*

Below, *software packages such as Extensis Portfolio allow you to catalogue and to keyword images so that later you can search for them quickly and easily.*

PERSPECTIVES

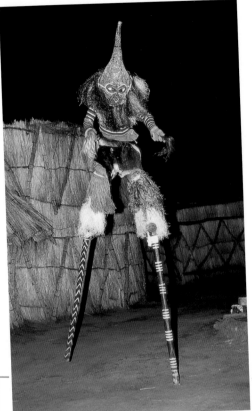

Left, taken almost exactly straight-on, with a mild telephoto, this shot has a flattish, natural perspective, close to how the eye would see it.

100

Beware: mixed perspectives

One of the most interesting possibilities of digital photography is collecting miscellaneous images for montaging later on the computer. However, if these have been taken from different viewpoints and with different lenses (see pages 42-45), then the chances are that the perspectives will not match up and the final result will look odd. This is particularly true of buildings (see pages 82-83).

If you are photographing a number of elements for montaging together then, as a rule of thumb, take everything from a similar perspective in order for them to fit together, and use a lens of the same focal length - or the same zoom setting.

Of course, you can create or remove perspective by distorting the image on the computer, but this isn't an ideal solution because it involves sacrificing image quality.

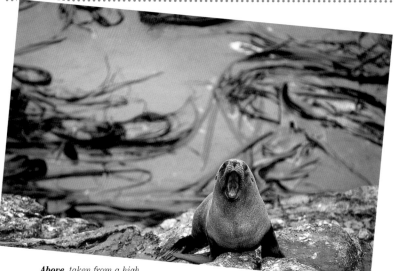

Above, taken from a high angle, this shot gives an appropriate sense of looking down from a distance. The flat perspective, the result of using a telephoto zoom setting, is perfectly acceptable.

101

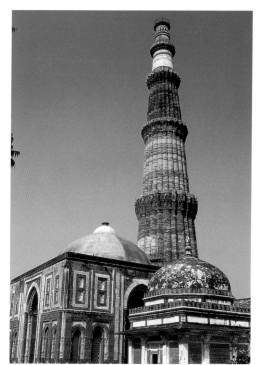

Right, this tower in India, photographed with a wide-angle zoom setting and a low viewpoint, has a very different perspective from the other shots on these two pages. They would be difficult to combine in a composite digital image.

There are times when even the best photographers have to compromise, including elements in a picture which they wish weren't there: prime offenders include telegraph poles and spots on the face of a favourite model. Until now, this has meant either spending a great deal of time while actually shooting the picture to ensure that everything is perfect, or employing a retoucher at extortionate rates to literally paint out these bits on the finished image. As a digital photographer, you are in a unique position: the image you take in the camera is work in progress, rather than the final image. Even simple retouching programmes allow you to make a series of interesting modifications to the image. Vapour trails from planes, litter and facial blemishes can be easily removed without leaving a trace. But rather than thinking of this as a way of salvaging bad photographs, regard digital manipulation as an integral tool in the creative process, and make allowance for it when you are actually taking pictures.

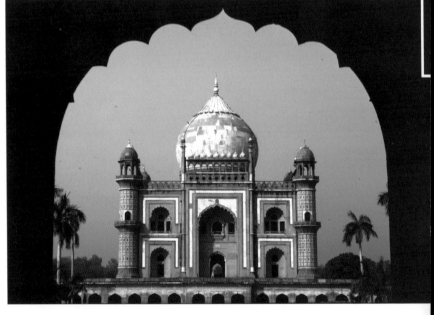

Is the landscape superb, but for a boring grey sky? Then take the picture all the same, bearing in mind that later you'll be able to drop in a dramatic sky from another photograph. Is the night cityscape truly amazing, except for a vast expanse of black sky? Then still take the shot, and later drop in a full moon, artfully placed to add depth to the composition. Here are some of the options in greater detail.

Above and above right, now you can take a picture even if it does have a boring, flat sky as you can change the sky later on a computer. Remember you should also look out for good skies to shoot for dropping in later.

103

Unwanted objects

As well as telegraph poles and vapour trails, cigarette packets and overhead cables are frequent menaces. All of them can easily be removed in 'home user' software packages such as MGI's PhotoSuite.

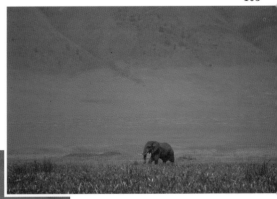

Above and left, *unwanted objects, such as these two safari vehicles, can easily be removed using short strokes with the cloning tool. Try to build up the background using light and dark areas in the same way as adjacent background. This allows you to take shots without waiting for vehicles or people to move out of the way as you know you can always remove them later.*

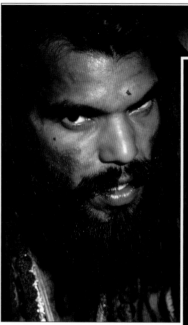

Left and below, blemishes on the face, such as spots or moles can be removed using the cloning tool of a programme such as Photoshop.

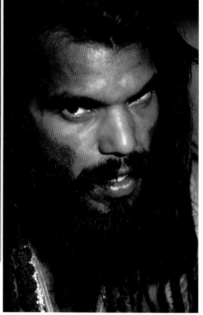

104

Blemishes on portraits

Not only spots, but shadows under the eyes are frequent hazards. The person being photographed, especially if female, notices them only too quickly in the finished result. Gone are the days when you needed a make-up artist to disguise them; software such as PhotoSuite or PhotoSuite 11 enables you to practise electronic plastic surgery, correcting noses, teeth and even changing eye colour.

Below and below right, using the dodging and shading tools you can lighten some areas to bring out details and darken others to show colour saturation. Only fairly subtle changes are possible here without the effect being too obvious - especially when lightening shadow areas.

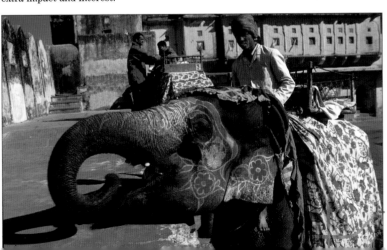

Above and right, red eye is when the flash on your camera reflects back from your subject's retina causing their eyes to glow red. On a computer you can correct this, so salvaging the picture.

Selective lightening and darkening

An all-too-common failing of picture taken with low- and medium-price digital (and conventional point-and-shoot) cameras is elements within the picture that are either too bright or too dark because they fall outside of the range of the camera's exposure latitude. Image manipulation software allows you selectively to lighten or darken parts of a picture to bring out more detail, and so to introduce a greater contrast range, giving extra impact and interest.

Removing 'red-eye'

Around 80 per cent of amateur flash pictures are spoilt by this effect, caused by flash shining directly into the subject's eyes and bouncing off the pinkish colour of the back of the retina. Most simple manipulation programs offer a tool just to remove red eye; PhotoSuite II does the job to a higher standard than the rest.

105

SHARPENING

Some digital cameras, or, to be precise, their image downloading routines, offer the option of sharpening images - as does digital imaging software.

The sharpening is apparent, not real: the software increases the contrast of adjacent pixels, rather than the number of pixels.

Nonetheless, it effectively increases the ability of a low-resolution camera to render detail, it can improve a poorly focused or blurred image and it can increase the quality of an image which has been resampled (see Resolution, page 110-111).

Digital imaging software achieves sharpening in a number of different ways. Simple sharpen filters take no notice of the image itself - they increase contrast overall. 'Sharpen edge' commands look for areas of significant colour change, normally indicating edges. These then have their contrast increased to produce the sharpening effect.

Above right,
resolution 960 x 720 pixels, no sharpening.

Right, *resolution 960 x 720 pixels using Sharpen Edges filter in Adobe PhotoShop.*

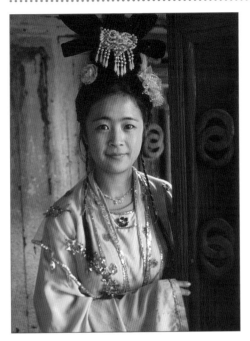

The most sophisticated way of sharpening is to use Adobe PhotoShop's Unsharp Masking. PhotoShop is a costly, high-level professional package, but some digital camera software offers this as an option. The software will look for any two adjacent pixels with a given difference in brightness values and then increase their contrast by a given amount. This has a similar effect to 'sharpen edges' but is much more responsive and controllable.

By their very nature, images which are intended to be viewed digitally can benefit a great deal from sharpening. If you have a low resolution camera, sharpening may even become an automatic procedure - at least for any image that is good enough to be preserved in an album, or even just displayed on a pinboard..

107

Above left, *resolution 960 x 720 pixels, using Sharpen filter in Adobe PhotoShop.*

Left, *resolution 960 x 720 pixels using Unsharp Mask filter in Adobe Photoshop.*

COLOUR DEPTH

The images on these two pages were created digitally using five colour depths.

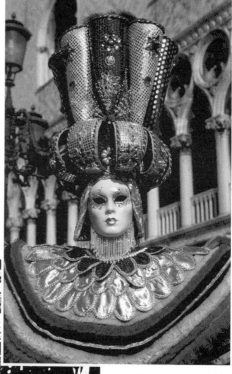

Above, 1 bit, diffusion dither to approximate greyscales.

Left, 1 bit, no diffusion.

Below, *8-bit colour, giving more only 256 colours - shows banding of colour.*

Above, *8-bit greyscale, giving 256 shades of grey.*

Right, *24-bit colour, giving more than 16.7 million colours.*

RESOLUTION

The resolution of an image has a direct effect not just on its quality but on the size at which it can be reproduced.

Different output devices - whether they be printers or computer screens - have different resolutions, which in turn affect the size of the output image. For instance, a computer screen has a resolution of 72dpi, capable of showing an image far larger than a 300 dpi printer. This is because the digital image has a finite number of pixels, expressed by a number of pixels wide by a number of pixels deep. A 300dpi printer will exhaust all the pixels in a 1280 x 960 resolution image in a 4 by 2 inch print. The same image would fill a 15-in screen.

Below, *1280 X 960 pixels*

Right, *320 X 240 pixels*

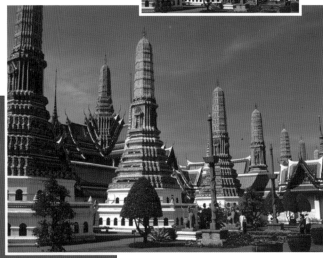

Right,
640 X 480
pixels

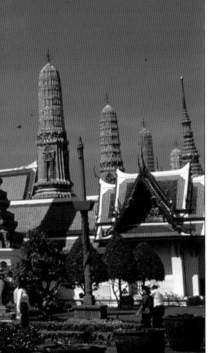

111

When making a composite picture from several digital images, you need to be aware that if you paste an image file which is saved at 72dpi into one which is saved at 300dpi, then it will drastically reduce in size. You can scale up the 72dpi image, but this will degrade its quality.

It is possible artificially to increase the resolution of an image by resampling: this means that the software adds new pixels, guessing their values. But this also reduces the sharpness of the image, so you should also run an overall sharpen command on the image to improve the quality.

Resampling can be the making of a digital image: by ensuring that it has enough pixels, you avoid the curse of digital photography - pixellation. This simply means that individual pixels are enlarged to such a degree that they are visible in the final image.

GETTING THE MOST OUT OF YOUR SCANNER

Scanners are still the most cost-effective way of getting
your photos into your computer. Although scanning is a
relatively simple process, you can get the most from your
equipment if you follow a few simple rules:

*Below, Microtek's
Phantom 330.*

Keep it flat, keep it clean

Flatbed scanners vary widely in their
quality and capabilities, but all work on
the same principle: photos are placed face-
down on a glass plate and the scanner lid
lowered on top (much like a photocopier).
No matter how good the scanner, if the
original is not perfectly flat on the glass, it
won't be sharp. If your scanner's lid
doesn't fit perfectly flush on to the glass
(and many don't), use a heavy book on top
of the original and close the lid on to the
whole lot.

If scanning transparencies on a flatbed,
then use tape if they won't stay flat. Make
sure that the glass platen is completely
clean before you scan in order to avoid any
marks appearing in your image. A major
consideration when scanning 35mm film is
dust on the celluloid surface: even the
smallest smattering will show up as black
dots all over your scan. Keep a compressed
air canister at hand to clean film and save
a huge amount of time.

Acquiring the image

Whether your scanner attaches to the PC
via the SCSI, Parallel or USB port, the
method for scanning is usually the same.
The software is in the form of a Photoshop
compatible plug-in or TWAIN acquire
module (both usually referred to as
'drivers'). It is accessed via a menu choice
from within your image editing
programme. Most scanners are supplied
with a 'host' programme of some sort as
the scanner acquire software cannot be
used on its own.

Check your resolution

ll scanners have a maximum optical
resolution (measured in dots per inch,
dpi). Whatever the maximum optical
resolution, the scanner driver software will
offer a range of options so that you can
scan at the resolution or size suitable for
your needs. Most drivers offer resolutions
above the hardware's maximum, achieved
by software interpolation (otherwise
known as an intelligent guess) and should
be avoided if possible.

To decide on your scanning resolution,
you need to know two things: first, the
resolution of the output device (printer or
screen) and second the degree of
enlargement or reduction of the original
you require.

This is best illustrated with a concrete
example: say you have a 600dpi scanner
and an ink jet printer. You want to scan a
10 x 8-in original to be incorporated into a
newsletter that will be printed on your ink
jet at 5 x 4 in. As a rule of thumb, you
should assume that you need an image to
be 300dpi for printing (regardless of the
printer's resolution, which could be much
higher - see Colour printing, pages 114-
115). Some scanning software will allow
you to define the final size and resolution
required, making life very easy, but many
only allow control of the scanning
resolution in dpi. So what dpi should you
choose?

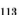

*Above and right,,
SilverFast scanning
controls.*

(depending on how well-designed the scanner driver is) and can give slightly better results. The flipside of this argument is that the higher the resolution of the scan, the bigger the file, the longer the scan takes and the heavier the demand on your PC's processor and disk space.

When using 35mm film scanners the sums are the same, except the driver software is usually more helpful and the degree of enlargement much higher. Example: a 35mm slide (size approx. 0.95 in x 1.42 in) needs to be scanned at about 2200dpi to be reproduced at 8 x 10 in on a 300dpi printer. Film scanner software usually allows you to define the size and resolution you need for printing and then does the sums for you.

113

Scanning an 8 x 10-in print at 600dpi will result in a 4800 x 6000 pixel (8 x 600 by 10 x 600) image. To reproduce this image at 5 x 4 in and 300dpi, it needs no more than 1500 x 1200 pixels. Thus the scan of the 8 x 10-in original needs to be performed at 150 dpi. Some scanners will allow you to type in both resolution and magnification, which in this case would be 300dpi, 50 per cent reduction.

If this all sounds complicated don't worry - you will soon get the hang of it. Whilst scanning at the right resolution is important, there is an argument for 'over scanning'. This is because if you have a low-end scanner it is sometimes preferable to scan at a higher resolution than needed, resizing as needed in your image editing application. This may actually be easier

Pre-scanning

Before you scan, it is usual to perform a 'prescan'. This allows you to see a preview of the scan on screen and to crop the exact area you need. Many scanning drivers also allow you to perform some basic pre-scanning corrections (such as brightness and contrast). No amount of Photoshop post-processing can make up for a poor scan, especially if the exposure is so wrong that highlight or shadow detail is lost. So experiment with the controls to find out how to optimize scans for your needs.

No amount of viewing your cybersnaps on your computer screen or TV can compare to the pleasure to be got from printing out a vibrant full colour copy on good quality heavy gloss paper. Personal web pages and video slide shows are all well and good, but the truth is, just about every digital photographer yearns for prints he can hang on the wall or send to grandma.

Fortunately, colour printing has come on in leaps and bounds in the last few years, making true photographic quality printing available to anyone at a cost that compares favourably to traditional 'wet' processing in the darkroom.

Printer types

There are basically only two types of colour printer in use in the home and small office; inkjet and dye sublimation. Other systems exist, such as Fuji's Thermal Autochrome system and Alps' MicroDry but the majority of colour printers at home are one or the other of the first two types. In fact the vast majority of printers bought by digital photographers are inkjets, for reasons of cost and versatility.

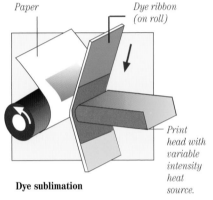

Paper

Dye ribbon (on roll)

Print head with variable intensity heat source.

Dye sublimation

Inkjet printers

Few computer peripherals have improved quite as radically as colour inkjets have over the last couple of years. The latest models boast resolutions of up to 1440 dots per inch and print on paper up to and including A1; all for much less money than a good digital camera. The traditional four colour system (CMYK, Cyan, Magenta, Yellow and BlacK) has been extended by

some manufacturers to a six ink system designed to produce more accurate, photo-quality images. As the hardware has improved, so has the sophistication of the software drivers used to control the printer heads and the special papers supplied to produce the sharpest prints. Inkjet printers work by spraying tiny bubbles of the different coloured inks on to the paper in special patterns that fool the eye into seeing all the subtle tones in the photograph. Although it uses a completely different system, Alps MicroDry system gives very similar results to inkjet systems and has similar print speeds and costs.

'Photo' printers

Two technologies can be considered together: dyesublimation and thermal autochrome, since in use the printers are very similar. The main difference between these photo printers and inkjets is size; whilst affordable inkjets are available in A3 and above versions, 'photo' printers are generally only available to home users that

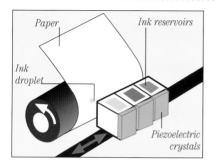

Paper
Ink reservoirs
Ink droplet
Piezoelectric crystals

Inkjet

use postcard-sized paper (or 6 x 4" at best). The prints produced are 'continuous tone' (not made up of discrete dots) which tends to make them look a little more photographic than the results from inkjet printers, but manufacturers are rapidly closing this gap. 'Photo printers' are often direct print devices that can attach to a camera's serial port for computerless printing (they all work with computers too).

INKJET PRINTING TIPS:
Check your resolution

Typically, inkjet printers have a quoted resolution of anywhere from 360 to 1440 dots-per-inch (dpi), but because the images are made up of patterns of 4 or 6 inks they have an effective resolution that is much lower. Whilst there is no set rule, you should try and set your images' resolution to between $\frac{1}{2}$ to a $\frac{1}{4}$ of the printer's quoted figure. This means that if you are using a 1440dpi printer you need images of about 360dpi for maximum detail (although after experimentation you may find 300dpi or even lower gives acceptable results). If you are using an A4 printer, this can mean a 30-35MB file— much larger than any digital camera picture. This simply means that you can't print your digital camera pictures at full A4 since they don't contain enough information in the form of pixels. To put it another way, an A4 image printed at 300dpi will hold approximately 3500x2400 (about 8.4 Million) pixels, so don't expect

your 1.2 million pixel images to fill the page.

Many digital cameras save their files at 72dpi as a default, which can result in printing problems. A 1024x1280 pixel digital camera is bigger than an A4 paper when printed at 72dpi, so resize to 300dpi in your image editing program (or choose 'fit on paper' if it is offered).

Use the right paper

Photo quality inkjet printing depends on a complex 'dithering': patterns of ink dots which are so small as to be invisible to the human eye. It is essential that the individual dots do not smear or spread (a phenomenon known as 'bleeding') and that their shape is preserved for the end result to look 'photographic'. In order to achieve this, printer manufacturers produce special coated paper which holds the ink without any bleeding or smearing, and which has a bright white base for accurate colours. It's expensive, but the difference in results will be well worth it. Shop around for alternatives to the manufacturer's own papers as many companies now market glossy inkjet paper at affordable prices.

Save as RGB

Despite the fact that the printer you are using is a CMYK device, do not convert your images into CMYK before printing them (as programs such as Photoshop will let you). Let the printer driver do the conversion for you, as it is optimised for the printer and will give a much better colour result.

115

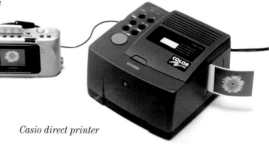

Casio direct printer

Creative computer projects

If you've not used image manipulation software before, we suggest you start with an all-round package such as PhotoSuite, whose range of step-by-step activities are designed to give the first-time user instant results. You get instructions on screen as you go. PhotoSuite's guided tasks are especially useful because they allow you to experiment with your own material – you're not restricted to tutorial data which is unusable at the end. Some of PhotoSuite's most interesting guided tasks are shown here. They make a useful introduction to the software – but remember there's much more you can do besides.

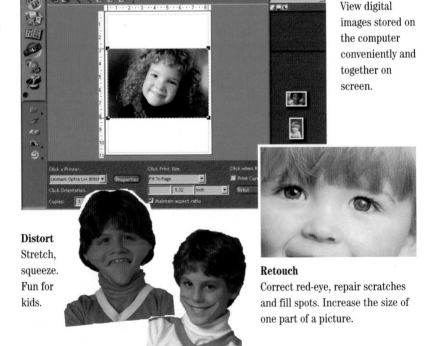

Simple interface
View digital images stored on the computer conveniently and together on screen.

Distort
Stretch, squeeze. Fun for kids.

Retouch
Correct red-eye, repair scratches and fill spots. Increase the size of one part of a picture.

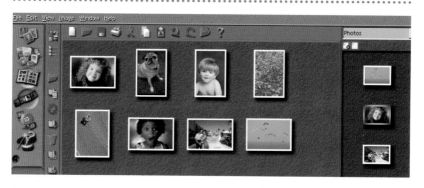

Creating an album

Arrange, caption and view on screen. Download to floppy or CD-ROM for storage.

Instant posters or magazine covers

– with the impact of professional graphic design.

Choose style and subject matter from a range of templates and images; customize to your own requirements.

Business documents

Flyers, selling documents, reports: all of them are better for a dash of

visual interest. Choose style and content from a range of templates; adapt to your own specific needs.

Greetings cards

Personalized with your own photos and text.

Congratulations

Special and artistic effects

Make a photo look like a watercolour or oil painting; soften the borders; make it black and white – and a range of other effects.

117

Software terms

There are many different software packages on the market, but they tend to use roughly similar language. We've adopted this language, based on that of Photoshop, the high-level image manipulation package.

If a term used in the book doesn't correspond exactly to the terms in your software, or indeed to those used in PhotoSuite, explore your software for the equivalent.

What software?

An all-round 'home user' package, such as PhotoSuite, will easily handle most of the creative projects in this section. All can be done in Photoshop, too. Other packages will handle many of the projects, but in some cases not so quickly or easily.

Your first experience of digital imaging software can be pretty daunting, with a vast array of tools and countless variations on display. To help you navigate, we've broken them down into families. You'll find most of these tools in all imaging and quite a few graphics products – only the names and icons may vary.

Selection tools

Use these to *select* the portion of the image you want to edit. The *marquee* tool lets you select a geometric area, typically rectangular or elliptical. Use the *lasso* for freehand selections and the *magic wand* to select a region of similar colour or tone.

Painting tools

Overlay colour on the image. *Paint buckets* let you colour large selections, *spray cans, aerosols* or *airbrushes* let you add graffiti. *Pens, pencils* and *gradient* tools may also be available. The strength of these tools can be varied between the subtle and the obvious.

Editing tools

This is where true image *manipulation* begins. *Clone* tools, for example, let you replace part of the image with another – useful for covering blemishes, road signs and the like. *Dodge* and *burn* tools allow selective modification of image density, using the techniques long used in the traditional darkroom. *Sharpen* and *blur,* colour modification and many others may also be available. See the following pages.

118

Selection tools

| Marquee | Move tool |
| Lasso | Magic wand |

Painting tools

Airbrush	Paintbrush
Eraser	Pencil
Clone	Smudge
Blur/sharpen	Dodge/burn
Pen	Type
Line	Gradient
Paint bucket	Eyedropper
Hand	Zoom

Brushes define the extent of many actions.

Dialogue boxes
Use sliders, push buttons or tick-boxes to apply effects. Here's an example from Photoshop, and another from PhotoSuite.

Some software packages use navigation tools, **below**, to lead you through effects.

Left, *before sharpening;*
below, *after sharpening.*

120

Increasing image sharpness
1 Select the whole image (if you want to sharpen every part of the photo) or the main subject. To select an irregular subject use the *Lasso* tool to draw around the edge

2 Select *Sharpen*. Some programs have multiple options for Sharpen, such as *Sharpen more* (like Sharpen, but with more pronounced effect), *Sharpen edges* (gives particular emphasis to edges and boundaries) and *Unsharp mask* sharpens only where needed.

3 Apply the effect

❖ **TIPS**
• Don't use this effect as an excuse for not getting the image sharp in the first place. Sharpen is not an electronic tripod, nor can it restore image detail not in the original image.
• Don't expect to correct severe blurring.
• Don't apply sharpen filters more than once. The image is likely to break into blocks (pixelate).

Image softening
-Makes a harsh portrait more flattering, or a landscape more romantic

1 Select the image, or image elements as before.

2 Select *Blur* and apply the effect. Where the effect can be varied, choose a minimal setting. Some software features the alternate (and preferable) *Soften*. This acts rather like a camera lens softar filter, retaining original image sharpness but diffusing edges and detail.

❖ **TIPS**
• Use soften and blur carefully. There is a fine line between a soft image and a blurred one.
• Look out for features such as *Smart blur* - this will retain contrast and automatically select areas to blur.

Before softening.

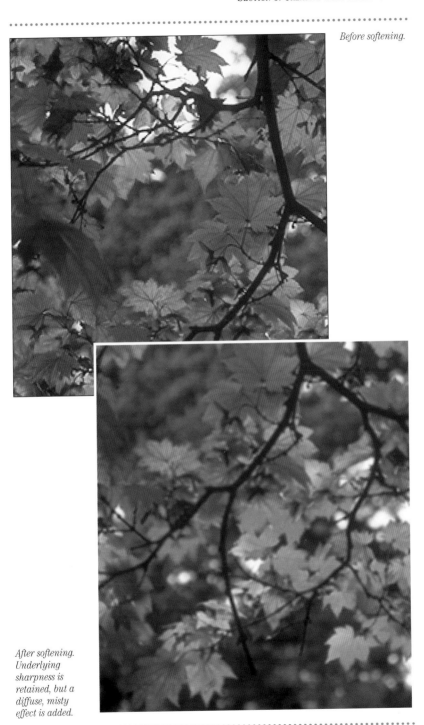

After softening. Underlying sharpness is retained, but a diffuse, misty effect is added.

Colour controls / the basics

The principal image enhancement controls (as opposed to manipulative tools) are *brightness, contrast* and *colour*. They work just like the equivalent controls on your TV.

Brightness
This control lets you boost the intensity of a dull (underexposed) image or 'dim' an overexposed one.

122

Contrast
-Controls the *tones* in an image. Increasing the contrast makes light areas brighter and dark areas darker. Conversely, decreasing contrast subdues bright areas and lightens dark zones. Colour information is unaffected.

Colour

Affects the colour saturation of the image, but without affecting the tonal (black and white) component. Adjusting this control intensifies or reduces the amount of colour in an image. At maximum, the colours become overbright and supersaturated. At *minimum* there is no colour information at all, leaving a monochrome image.

123

❖ **TIPS**
• Just as with a television picture, the optimum image results from careful and judicious manipulation of all three controls.

• Some software includes an 'Auto' button that optimises all levels at a single stroke.

• When you become adept at the manipulation of basic controls, *Level* controls allow more precise adjustments of the image.

**Colour
compensation**
-Correct colour casts
caused by tungsten
lighting or lighting
taken in extreme
conditions.

1 Assess the nature
of the colour cast.
Tungsten or
fluorescent lighting?
Overcast skies?

2 Select *Colour
balance.* In some
software, this may be
called *Adjust colours.*

Tungsten

124

Correct

3 Use the sliders in the
dialogue box to 'dial
out' the colour cast.
Increase blue and
green to compensate
for pictures taken
indoors by tungsten
lighting.

Add red or magenta
and yellow to
compensate over-blue
shots; add magenta to
compensate for the
green cast due to
unbalanced
fluorescent lighting.

4 Click *OK* to apply the
compensation.

Changing colour
Aim: to give this cottage an ethereal, unworldly look.

1 Select *Hue/saturation*.

2 Adjust the sliders and watch the effect in the *Preview*. Colours are being 'moved' sequentially.

3 When happy with the colours click *OK*.

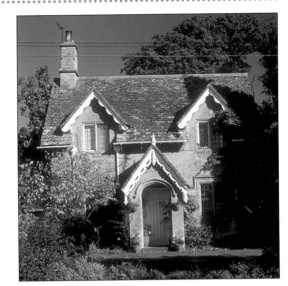

125

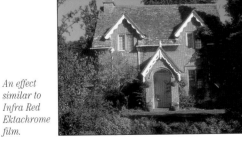

An effect similar to Infra Red Ektachrome film.

❖ **TIP**
• False colour images can be very powerful, but don't overdo them. The effect can quickly become wearisome. More subtle uses for these effects are explored in later projects.

1 Zoom in on the offending mark.

If you've used a scanner or even PhotoCD to capture a digital image, the chances are fairly high that a fair few flecks of dust will have crept in. Using the *Clone* (sometimes called the *Rubber stamp*) tool, you can belatedly clean up your shots.

2 Select the *Clone* or *Rubber stamp* tool. Set the *brush size* (in imaging software, brush sizes apply to most tools, not just the paintbrush) slightly wider than the width of the blemish.

3 Select part of the image near to the blemish that can be 'cloned' over the offending mark.

4 Brush over the mark and watch it disappear.

5 Zoom out and check your work.

6 If the mark crosses several image elements you might need to 'reset' the clone tool to deal with each area separately.

Left, *part way through the process of removing the mark.*

Above, *the cleaned-up photograph.*

❖ **TIPS**

• Most image manipulation software and even some slide or print scanner software features *auto scratch removal* routines. They can make good a badly marked image quickly, but may also soften the image.
• Use the *Clone* tool to clean up other features on your shots. With practice, you'll soon be able to remove the TV aerial from than otherwise unspoilt Cotswold cottage, or even remove whole cars.

Above, *the original picture;*
right*, car in the background removed. This is especially worth doing if you want to use the photo on a flyer to sell your car.*

····································

Teams of specialist engineers
have struggled to minimize
the Leaning Tower of Pisa's
tilt. Now, most digital imaging
packages enable you to cure
it completely in minutes.

1 Use the lasso tool to select the
tower as shown. You don't need
to follow the tower's contour very
closely.

2 Rotate the image until it's vertical. This usually involves dragging on one of the top corners.

3 Use the clone tool to fill in the missing sky and any portions missing from the basilica. Also tidy up at the base of the tower. The figures standing in front of the tower are too tricky to repair - simply remove them, filling in with the clone tool.

129

DUPLICATION

The *Clone* or
Rubber stamp tool
is fundamental to
digital image
manipulation. It's
very useful for
retouching, as
shown by many of
these projects, but
don't forget its more
fundamental, and
obvious role.

1 Prepare the background by painting out
the intrusive figure, the railings and hose
pipe spray - all with the *Clone* tool. Make
sure that there's enough clear water for
two more dolphins.

2 Load the *Clone* or *Rubber stamp* tool slightly to the left of the left-hand dolphin and then set it to copy to the right of the right-hand dolphin. Complete the operation by dragging from top to bottom of the image area to be duplicated, not forgetting the wash.

3 Using the *Clone* tool again, disguise the join in the water; result: dolphins doing synchronised swimming.

REPAIRING A BADLY DAMAGED PRINT ····························

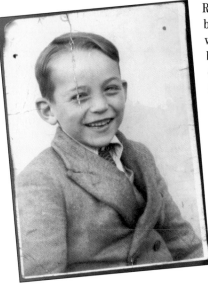

Retouching a badly damaged print used to be a job for the professional, who might well spend hours patiently 'spotting' out blemishes. Digital imaging softare enables anyone to do the work, without special skill - but you'll still need patience.

1 Scan the print to convert it to digital form: easy if you have scanner. Otherwise have it done by a bureau, or a friend. Scan it as large as possible.

2 Correct the tonal balance. This means deepening the blacks, and whitening the whites, which may have lost their proper values as a result of the scan, or of age. Some software has an automatic tonal balance correction facility; or you may have to use a histogram chart, inset below.

3 Improve brightness and contrast. All digital imaging software offers this facility. Some high-level packages create a display, below, from which you can choose the best combination of brightness and contrast.

132

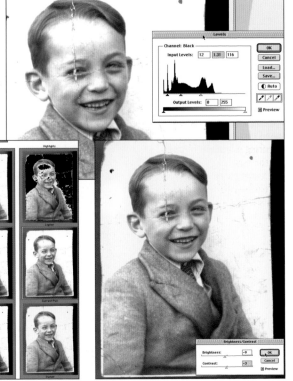

4 Now start to retouch. First enlarge an area to be worked on. Use the copying or cloning tool, a feature of most imaging software. Painstakingly select minute areas of identical tone close to the scratch or spot. Move it on to the damaged area, painstakingly filling, bit by tiny bit. Choose a small `brush' - you'll have a choice - see inset panel.

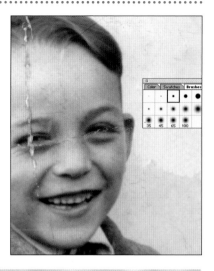

5 Dealing with the background. If it is damaged, and you don't want to spend time repairing it, cut out the main image and replace the background with a soft texture.

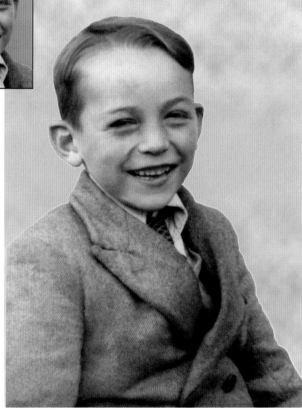

133

Repairing 'red-eye'
- or turning a little devil back into a little angel. Red-eye, the reflection of flash from the retina, can spoil an otherwise perfect portrait. It can be removed in a few simple steps, as here.

1 Zoom in on the eyes.

2 Click inside the red eye with the *magic wand* tool. A moving, dotted line indicates the selected area.

1

3 If you need to enlarge the selected pupil slightly (if all the red has not been selected), hold the shift key down as you select again, adding to the selection.

2

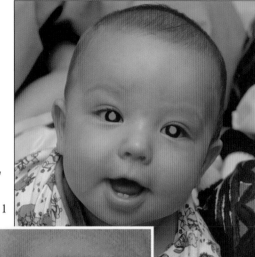

❖ **TIPS**
- Remove 'green-eye' in pet photos in exactly the same way
- Some software, for example Photo Suite II, features auto red-eye removal functions. This can achieve the same effect at a stroke.

3

4

134

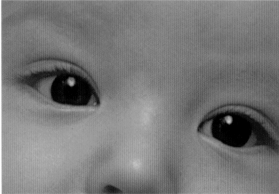

4 Replace the selected colour with black. Use a *'fill'* tool (such as the *paint tin*, or a large *brush*).

5 Add realism (and a little sparkle) by putting a small white 'catchlight' on the new pupil, using a fine brush or pencil tool.

Removing skin blemishes
1 As before, zoom in on the area to be corrected.

2 Select the *rubber-stamp* or *clone* tool.

3 Activate the tool by selecting a nearby area of skin and 'paint' it over the blemish.

 1

4 Most software allows for 'soft' edges and a degree of translucency. Exploit these for a more gentle effect.

135

2

❖ **TIP**
• Use the same cloning technique to remove distractions from the background.

3

5 Zoom out and assess the effect. Here chickenpox has been cured the easy way.

A distracting, sharply focused background spoils all too many outdoor portraits, especially if taken in a horizontal format, like this original, *above.* Re-framing it in the computer, *right,* was simple, and eliminated much of the background - but what was left still spoilt the shot. A little more work was needed:

136

1 Make a scan of the print. Correct any colour changes caused by the scan.

2 Cut out the figure and save. Feather the edges.

3 Return to the background. Soften and blur as much as possible.

4 Merge the two images.

1

With practise, you can use the same technique to blur *foreground* detail also, as in the case of these ponies. Here the *soften* filter has been applied to the entire image to give an even softer feel.

2

These results were obtained in a consumer software package.

Simulating differential focus and depth of field

1 Use the *lasso* tool to select your foreground image element. Don't worry about being absolutely precise when outlining, but take care not to include any background detail, between a subject's legs, for example.

138

2 Use the *Feather* option to soften the boundary of your selection and avoid an abrupt change.

3 Make the background the active area by selecting *Inverse*.

4 Apply the filter blur or blur more. Repeat until the desired level of unsharpness is achieved.

3

2 Now apply the *Motion blur* effect. Use the dialogue box to define fast or slow motion

3 Apply *Radial blur* to the wheels to give an impression of rotational motion. Again use the dialogue box to match the degree of application to the subject.

Creating a sense of movement
You can also use the technique, described opposite, to give a sense of movement to a static object.

1 Use the lasso tool to define the traction engine, including the smoke and the spokes of the wheels.

139

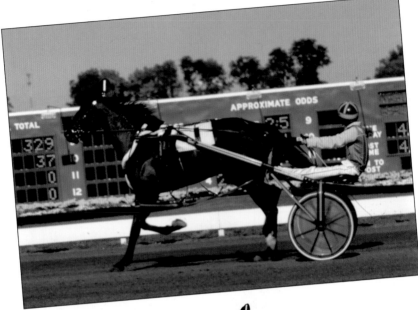

140

The basics of digital blur are explored in detail on the previous two pages, and are also readily achieved in-camera (pages 92-95).

Here's what to do with an original, like the one *above*, which should have been given a pronounced panning effect, but wasn't. Both image and background are too sharp, making the picture static and boring.

1 Cut out the horse and buggy. Save to another layer.

2 Turn to the motion blur facility in your software and set it to give horizontal (zero degree) blur. Experiment with the amount of blur, and when you think it's right, blur the whole picture.

3 The result: far too messy and impressionistic. So, select the cut-out horse and buggy, feather their edges, leaving the rest sharp, and combine the two layers. The cut-out image, same size as the original, will sit over it exactly, so no filling-in is needed.

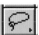

1 Select the *Lasso* tool.

2 In the *Lasso options* pop-up menu select a feathering figure. The feathering (expressed in pixels) defines the degree of softness of the selection boundary: zero will give a sharp line, following your selection.

3 Draw around the image element you wish to select. Draw with care, but don't worry about being too precise.

4 Select *Copy* from the *Edit* menu. Your isolated element is now in the clipboard.

142

5 Select *File* then *New*. Click on *OK*. This gives you a new, empty image space - a blank canvas.

One of the most powerful uses of digital imaging software is the creation of montages - images that comprise any number of elements from disparate sources. On this and the following pages you'll discover the essential basic techniques. The steps on this page are described in PhotoShop.

As a first step, try isolating an image element from its surroundings.

6 Now paste in your saved image element. Select *Edit* then *Paste*. Your selection should now be on the blank canvas (depending on the original object size, you may need to alter your page size to accomodate the image).

Note how setting a feathering amount (in this case five pixels) has given a soft edge. If you had set no feathering, the result would be harsher and less forgiving of drawing mistakes.

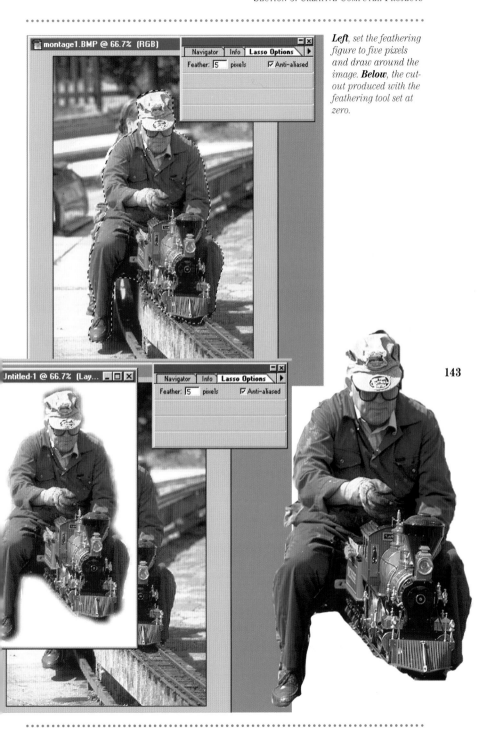

Left, set the feathering figure to five pixels and draw around the image. *Below*, the cut-out produced with the feathering tool set at zero.

143

New from Current Photo

New from Other Photo

Photo Package

Free Form

Comic Book Layouts

Photo Albums

Movie Posters

144

Having isolated an element (previous two pages), now try combining several elements to make an electronic collage. PhotoSuite includes a project feature for this very purpose.

Free Form

1 Select *Projects* at the *Navigator*.

2 Select the pull-out option *Collage*. This prompts you to begin with a new, or existing, image and gives several collage options. Try *Freeform* first.

3 Import your first image. From the *File* menu select *Get photos....*

4 When your chosen image appears on the collage, use the *handles* to change the size or even rotate.

5 Add further photos in the same way. If you have some image elements (like those collected in the previous project), add these too. You can reposition individual images at will. You can also interchange the *layers* to place one image behind another.

6 To finish off this collage, add a *title*, and give it depth with a *drop shadow*. Activate the *Text* and *Drop shadow* icons respectively to add these features to your collage. Finally give the main photo a feathered edge using the *Soft edge* option.

❖ **TIP**
• As you become adept at montaging, and especially at feathering, you will be able to place objects together almost seamlessly.

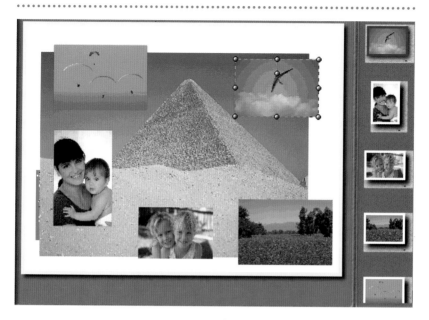

Above and *below*,
some simple montaging
possibilities.

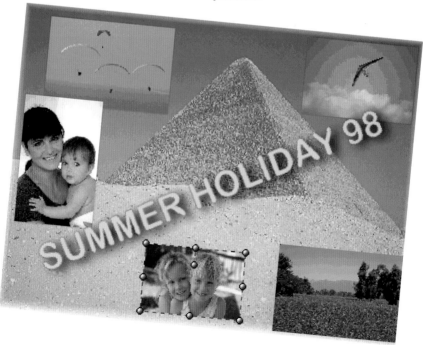

The previous four pages have been about isolating and combining elements. These skills are the key to successful montage. But to make your montages even more convincing, here are some tips and tricks.

Above, layers in Photoshop.

Using layers

The advanced software package, such as PhotoSuite (and Photoshop) use **layers** to build up a picture. By placing each image element in its own layer, you can reposition at will. If you don't like a particular element, turn off the layer and re-assess. You can make layers translucent by using the Opacity slider on the layers window.

Balloon 1 and balloon 2

146

Plain backgrounds
Make combining images easier. Look at the two balloon pictures, *opposite*. The balloons were selected and placed against a more uniform sky. Small errors in feathering were minimized as a result.

Black and white
Build your confidence using monochrome images – less critical than colour.

Cut out ballons placed in a new sky

> ❖ **TIP**
> • Successful montages are not easy. Aim modestly to begin with. Remember, digital imaging is *fun*.

balance for each additional element until it matches the main scene.

147

Image bleed: image elements have been too crudely selected and feathered. Either use the *lasso* more accurately, or *clone* the surroundings up to the edge of the subject.

Watching the light
Look at the crude montage in the sunset picture, *above*. It's a good first attempt, but let's take a *critical* look at it.

Direction of light: the lighting on the lighthouse and balloon do not agree with the sunset.

Colour casts: the *colour temperature* of the main scene does not match the added elements. Adjust the colour

REACH FOR THE SKY .

A dramatic sky makes all the difference between an average landscape photograph and one worth a second look. The trouble is, you usually have to wait for hours, even days, for the moment when a suitably interesting sky slots into place.

Or rather, you used to have to wait. Once you've got used to the basics of montage (see the preceding pages), you can merge a great sky with a an interesting foreground subject. With care, the result can be seamless.

1 Choose your originals. For first experiments, select a foreground object that has a simple outline, and contrasts strongly with the background. It helps if the horizon is a straight line – or mostly straight.

2 Cut out the background sky. Use the Trace tool, painstakingly outlining the edges of the stones with your mouse.

Essentially, there is no short cut, but some software, such as PhotoSuite, has an automatic edge finder which will help. Minor irregularities can be corrected later – see step 4.

3 Keeping the foreground image open, also open the sky image. Select the whole of the sky and drag it on to the foreground image. Use the dragging facility to adjust the layout until it looks right. Then ask the software to combine the two.

4 Soften the edges of the stones and horizon with the feathering tool.
Then adjust the colour balance and contrast of the overall new image.

1 Choose the pictures on which you want to work.

2 Cut out the cowboy and horse and *Save* with a transparent background.

150

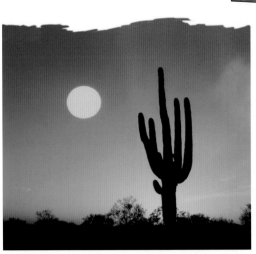

Just having some fun is an important aspect of digital imaging. Even if the results are of interest to no one but yourself, you'll gain useful experience of your software's capabilities. This project was achieved in PhotoSuite, and uses the montaging skills described on the preceding pages.

3 The cactus and moon image was just right for this project, except that it needed to be made taller. The sky was extended using the *Rubber stamp* or *clone* tool.

4 *Paste* the rider and horse into the sky and adjust its final position with the move tool.

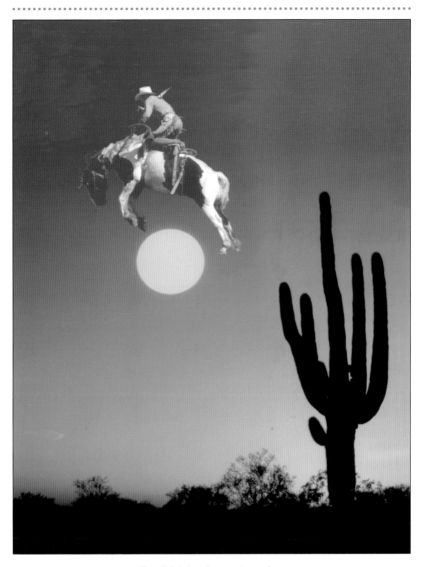

Fanciful, but perhaps not so useless after all. If it was you, your spouse or one of your kids on the horse, it might make an amusing greetings card.

CREATING A REFLECTION ..

A mirror image
reflected in
water can often
be the making
of an otherwise
dull photo.
Remember that

it will usually
be necessary to
re-format the
shot in order to
accommodate
the extra depth
of image.

5 For realism,
lighten the
reflection. Select
the whole water
area and then
go into
*Brightness/
contrast,* reducing
the brightness for
the final result,
opposite.

1 Enlarge the canvas size to double
the height of the original, or more.
Move the photo to the top of the new
canvas.

2 Duplicate the original, saving it to
a new layer. Position the duplicate
below the original.

3 Flip the duplicate image upside-down.

4 Find the *Wave distort* effect in your
software. Experiment with settings –
the bare minimum tends to work best.

..

153

BASIC MONOCHROME EFFECTS

On these pages, Photoshop has been used to emulate some traditional – and not-so-traditional techniques

Toning
A touch of Victoriana.

1 Take a colour or black and white image. If a mono image is stored as a *greyscale*, convert it to *RGB*.

2 Toning effects generally work best with bold, graphic images, with above-average contrast. Adjust the contrast as necessary.

3 Select the *Colour* or *Saturation* dialogue box. Reduce saturation to zero.

4 Click on the *Colourize* box - don't be alarmed if the image turns salmon pink and the saturation slider sets to 100. This is the default 'tone' (Photoshop).

5 Adjust *Hue* to achieve different tones. Try +20 for sepia, -90 for a cool violet. Adjust saturation and lightness to get more subtle effects.

Below, RGB

Polychrome
Don't feel constrained to emulate 'traditional' tones and techniques. For unusual but powerful toning effects, start with a colour image. Reduce saturation to around 50 per cent but do *not* select the colourize box. Now adjust hue as before.

155

Above, top: *Hue and Saturation controls in the Colourize box.* ***Above:*** *sepia effect.*

Grain
Add atmosphere to moody or gritty subjects by simulating grainy emulsion.

1 Select the whole image.

2 Select the effect *Noise* to access the Noise dialogue box

3 Vary the amount of noise until the desired degree of grain is seen in the preview. Prevent colour-speckling by clicking on the *Monochrome* box.

4 Apply the effect

❖ **TIP**
Apply the *Sharpen* command several times to achieve a bolder, more graphic 'grain' effect.

Many a pleasant, but everyday colour portrait can be made more displayable by converting it to monochrome. Black and white, perhaps because of its simplicity, can give a portrait a certain dignity and permanence compared with colour.

1 Convert to greyscale - in other words, black and white. This is possible in all digital imaging software, low-level or professional. Just select the whole image, including the background, and click on the command button.

2 Some packages also enable you to convert to duotone. If you use this option, be restrained. Soft sepias are generally the way to make a photo look older, but here it is simply used to soften the face.

3 To make the portrait more formal (and worth framing) than a squared-off snapshot, select an oval mask and remove the background outside the mask. These are easy operations in PhotoSuite II and indeed most digital imaging packages.

4 Soften the edges using a feathering tool.
The key to this is restraint.

PANORAMAS ..

Above, *two images with approximately 40 per cent overlap.*

1 Take a series of photographs, left to right, encompassing your intended panorama. Aim for a 40 per cent overlap between images to give the panoramic software sufficient information to correlate images.

2 Download the images into the computer and import into the Panoramic software's buffer.

158

These two pages explore the action of purpose-designed software for stitching together photos into panoramic shots.

3 Select a *Lens*. The software needs to know the perspective of your camera lens. Express your selection as a 35mm camera equivalent – check the camera manual.

4 Select *Build panorama* and sit back.

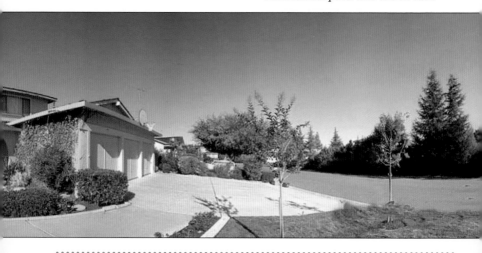

Most panoramic software stitches images together automatically (here we have used Live Picture's *PhotoVista*).

5 *View* your panorama.

6 If you need to make any adjustments to the final image, open that image in your image editing software and make changes to contrast, colour, and so on, as required.

Right, *stiching in action*.

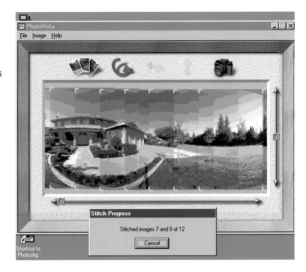

❖ TIPS

• The best panoramas are taken on bright, overcast days. Sunny days cause wide contrast variations. Whilst these reflect reality, they lead to an 'uneven' pictorial result.

• Resist using filters – polarisers especially will exacerbate contrast effects.

• For best results use the highest resolution camera mode possible (bear in mind that high resolution images take time and much RAM to process.)

• For swiftest results use a lower resolution

• Experiment. Using a digital camera, costs are minimal, so have fun.

• Try pre-processing each image in Photoshop or Paintshop to create a more graphic result (start with a four-level posterise).

159

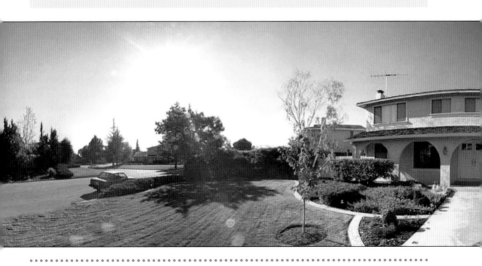

They're fun, and, most important, they encourage you to experiment. But how much long-term satisfaction they give is, well, up to you.

On this page is a range of mirror-type distortion effects easily achievable with low-level digital imaging software.

Opposite are a range of 'painterly' effects, also generally available on most imaging packages. Perhaps they're used to best effect as one-off images on party invitations or greetings cards, when removing an image one step from original photographic reality gives it an appropriate status.

161

Some programs, such as PhotoSuite, allow extreme image distortions – warping. Use this feature to produce wacky effects or to generate caricatures.

162

To apply the Warp effect using PhotoSuite

1 Select the *Photos* button on the Navigation panel.

2 Select an appropriate subject.

3 Click on the *Touchup & transform* icon and select *Warp* from the options displayed.

4 Choose a *Warp* tool from the selection. Experiment with each option, and observe the manner in which the image is pinched and stretched.

5 Use the slider control to exaggerate or diminish the effect.

6 When you are happy with the result, select the *Apply* button. Only now are the modifications applied to the photo. Note that you will be prompted later to save these to your hard disk.

Touchup & Transform

7 Use the *Reset* button to return to the last (saved) version of the photo.

❖ TIP

• Don't just use distortions on people. Caricature your dog, car or even buildings.
• Effects can be unpredictable, so learn through experimentation. Remember that your image is not permanently changed until you finally *Save*.

PATTERNS

Cutting out digital images, then repeating them to create patterns often results in an image around which an invitation, a logo or greetings card can be successfully designed.

1 Cut out the parrot and copy it, say, eight times - using the *Clone* or *Rubber stamp* tool as described on pages 130-131. Also cut out the ball.

2 Think about what size the ball needs to be - bearing in mind that it must fit inside however many parrots you decide to have.

3 *Paste* copies of the parrot into the ball, each time changing the angle of *Rotation* until the pattern is complete.

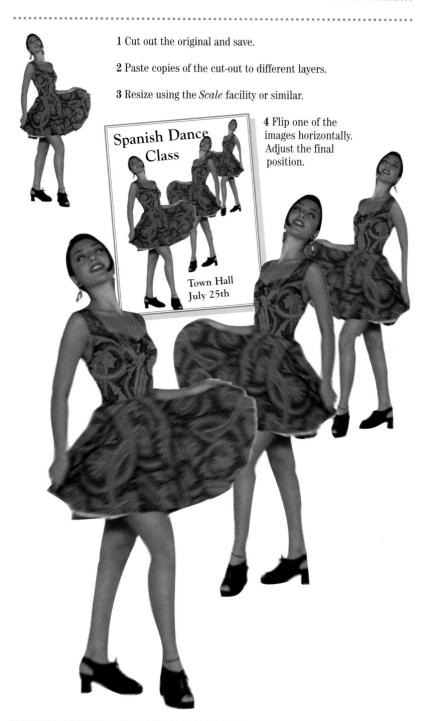

1 Cut out the original and save.

2 Paste copies of the cut-out to different layers.

3 Resize using the *Scale* facility or similar.

4 Flip one of the images horizontally. Adjust the final position.

Spanish Dance Class

Town Hall
July 25th

165

CREATING ALBUMS AND SLIDESHOWS

Keep track of your prized images by setting up electronic albums. PhotoSuite is one software package that lets you store – and show – your images.

Creating albums
1 Get organized. Think of the albums you might need and write them down.

2 Create the first from the *File* menu: select *New*.

3 In the dialogue box, click *Album*.

4 Give the album a name in the *Album name* text field.

5 Choose a thumbnail size for the album from the drop-down menu. You'll be able to see more with a smaller size, but they will be less clear. A useful compromise size is 96 x 96mm.

6 Click on *OK*.

7 Add photos from the *File* menu. Select *Add Photo*.

8 Browse the available photos.

9 To save your album select *Save* from the *File* menu.

10 Repeat for additional albums.

❖ **TIP**
You can also store video clips and sound files in an album.

Slideshows
Present your albums – and other images – as electronic slideshows.

❖ **TIP**
Re-order slides by dragging and dropping in the storyline.

1 Place your images into PhotoSuite's *Library*.

2 Select *File* then *New* then *Slide show*. The slideshow dialogue box will appear.

3 Give the show a name in the *Name* field.

4 Use *Slide show options* to alter photo size, duration and background colours.

5 Drag photos from the library and into the *Storyline*. Alternatively, choose *Add photo* from the *File* menu to browse the available images.

167

You may want to publish your images on the Internet to share with others, distant family members or to promote your imaging skills.

Before setting out to produce your own Web Gallery you'll need:

• An Internet connection account and appropriate hardware (i.e. a modem, or ISDN card).

• Software for web building (such as Filemaker *HomePage* or Adobe *PageMill*).

• PhotoSuite enables you to visit the web straight from the software, and to build your own web site.

Claris Home Page

AOL Internet server

Converting your image to web format
First you will need to convert your image to a format that the web can handle. You can do this in either the image editing or the web-building software.

1 Open your selected image.

168

Convert Image to WEB ☒

Target Window Size
- ⦿ 640 x 480
- ○ 800 x 600
- ○ 1024 x 768

Actual Size
569 x 380 pixels

[Convert] [Cancel]

Left, Convert

are transmitted faster, but at lower quality.

2 Select *Convert to Web Format.* You'll typically find this function on the Image menu.

5 Post the image on your web page using your web software. It is similar to pasting into a word-processing document.

3 A conversion dialogue box will appear. Select a target size for the image. This is the nominal size the image will appear on a screen of your viewers. Virtually all viewers will be able to handle 640 x 480, but progressively fewer will be able to display larger ones.

❖ **TIP**
• If your software package does not feature web conversion options, save your image in .jpg (or jpeg) format. You will have to adjust the size manually. Then import into your web software (some web page software will convert 'foreign' formats automatically).

4 Select *Convert.* Define the degree of compression used to store the image using the *Image Quality.* High compression files

Below,
Homepage

Untitled.html

Normal

169

One area of continuing confusion for digital photographers is that of graphics file formats. What are the differences and which should you use?

Why the different file formats?
The way in which the binary information is stored in a file is referred to as its format. Whilst there are many proprietary formats around (Photoshop's own .PSD format is a good example), the problem occurs when someone without the same program needs to open or view the file. There is also another consideration: some file formats take up considerably more disk space than others to store the same information. This can be due to simple efficiency factors or, more commonly, data compression. With the growth in digital imaging, a plethora of file formats has emerged that are both compatible with a wide variety of software and make efficient use of compression (squashing).

Compression
Files are made up of bits of information; 8 bits make a byte, 1024 bytes make a kilobyte, 1024 Kb make a megabyte and so on. Because every dot in a digital image has to be described in terms of position, colour and brightness, these bits and bytes soon build up. In fact scanned photos are notoriously large – a full resolution A4 photo can be over 30 megabytes and even the most basic digital camera creates files of nearly a megabyte. When you consider that digital camera storage is rarely more than a few megabytes, and some megapixel cameras can produce files of 4-6 megabytes, you can soon see why some form of compression is necessary. This is also true of any files that need to be transferred, either over the phone lines (the Internet) or just down the serial cable from camera to PC. Sending a file of many megabytes down these wires is a bit like trying to fill a swimming pool with a hosepipe: very slow.

There are two forms of compression, lossless (where the original information is exactly preserved, but space savings are modest) or lossy (where some image information is sacrificed to allow huge file size reductions). Most digital cameras use some form of lossy compression. The principal image file formats are listed below.

JPEG (file extension .JPG)
A lossy compression method that can achieve huge space savings (up to 1/100th of the original size). This is the most common digital camera file format. It supports true (24-bit colour) and CMYK (needed for professional printing) and can be read by just about any application.

TIFF (file extension .TIF)
Widely used in professional printing, TIFF files can be compressed using a lossless system (called LZW) but this can only achieve a 50% saving at best. TIFF supports CMYK, 24-bit colour and is compatible with 99% of imaging software. TIFFs are ideal for archiving whenever quality is of paramount importance.

GIF (file extension .GIF)
One of the earliest universal formats (it's full name is Graphics Interchange Format), GIFs are nowadays only found in use on the internet (and specifically web pages). They are small (due mostly to their 256 colour maximum) and use a lossless compression system (LZW again). Because they support neither 24-bit colour or CMYK mode, they are of little use to the digital photographer.

BMP and PICT (file extensions .BMP and .PCT)
The two 'native' formats of Windows and Macintosh systems respectively. Not generally used in digital photography.

Encapsulated Postscript (file extension .EPS)
Used in professional page layout systems and of little interest to the average digital imager. EPS files can contain extra information such as clipping paths that are used in desktop publishing.

Application Native Formats
Many digital imaging programs have, in addition to support for all the common graphics formats, their own native file formats. A good example is Photoshop which has the .PSD format for its own files. The advantages of native formats are twofold: speed of opening and preservation of application-specific features (such as layers in Photoshop). Formats like .PSD rarely offer any compression and are usually reserved for 'work in progress' files. Once the image has been saved as another format (such as TIFF), information about layers, etc. will be lost forever.

SOFTWARE ROUND-UP

In this last section of *The Digital Photography Handbook*, the creative projects have mostly been executed either in PhotoSuite or in PhotoShop. These are not the only image manipulation software packages available, so here's a review of the wider software scene. We've selected the most interesting, and popular, under appropriate headings.

171

Prices given relate to buying one copy from a mainstream retail source: in other words, the maximum you might expect to pay, and were correct as the book went to press. However, prices change rapidly in this field. There are also wide price variations between different sources and different countries and often software is bundled with hardware at an inclusive, discounted price. Shop around before committing.

Essentially for image editing
PHOTOSHOP (Adobe Systems, £600/$1,000). The Rolls Royce of the image editing world. Though expensive, it's capable of addressing almost every imaging need, and has long been the unofficial industry standard. Can be baffling for newcomers.

PHOTODELUXE Adobe Systems, £60/$100). Basic Photoshop tools but with a friendly, step-by-step approach for newcomers, and a go-it-alone approach for the more experienced.

PAINTSHOP PRO (JASC, Inc, £60/$100). A paint program that has grown into a potent image editing tool. Check it out first on the Internet at www.jasc.com.

LIVE PIX (Live Pix, £40/$65). Slightly limited but very fast, particularly for large image files – and an excellent price.

SATORI (Spaceward Graphics, £350/$580). A fast performer, but with a quirky interface.

Image editing and cataloguing
PHOTOSUITE III (MGI, £60/$100). The total solution to image acquisition, editing and storage. The ideal all-in-one package for the non-intensive image manipulator and archiver. Offers comprehensive Internet facilities and excellent guided projects.

PHOTORECALL (G & A, £100/$160). Limited image editing, but very extensive cataloguing and searching facilities. Ideal for large family archives.

Image editing and graphics
COREL DRAW! (Corel, £250/$400). Includes PhotoPaint 8, a credible image editing package that is fully integrated with the main Draw! package. Delivered on three CDs, with many useful extras.

Cataloguing, filing and storing
K5 PHOTO (Keybase, £200/$325). An advanced image filing system built by photographers who needed to archive their own materials.

PHOTOWALLET (NBA, around £100/$160). Compact program, delivered on two floppies. Comprehensive filing options, but with limited editing facilities. Professional version available at around double the price.

Special purpose
PHOTOVISTA (Live Picture, £100/$160). A simple but powerful panorama software, which stitches together individual shots to create seamless panoramas. Fully automatic, but with full manual override for fine tuning.

SUPERGOO (MetaCreations, £50/$80). A brilliant package for building and editing face pictures. Turn shots of yourself or friends into grotesque or compelling caricatures in a few seconds.

TECHNO TALK

An A-to-Z glossary of digital imaging terms, including a number not used in this book.

A

Anti-aliasing Removal of a jagged edge in digital images by averaging adjoining pixels to create a smooth blend of colour.

AGP Advanced graphics bus which speeds screen redraw considerably.

B

Bit A binary digit – basic digit quantity – representing either 1 or 0.

Bitmap An image made up of dots, or pixels. All digital cameras produce bitmapped images.

Byte The standard computer file size measurement. Contains eight bits. Other common units include kilobyte (K – 1,024 bytes), megabyte (Mb – 1,000K), and gigabyte (Gb – 1,000 MB).

C

CD-ROM A non-rewritable digital storage CD often used to provide software.

CCD A charged coupler device. Converts light into electrical current.

CMY, CMYK Cyan, Magenta, Yellow. Colour printing model used by dye-sub and low-cost inkjet printers. CMYK adds black (Key) and is used for all professional printing.

Colour bit depth The number of bits (see under B) used to represent each pixel in an image. The higher the bit depth, the more colours appear in the image.
 1-bit colour: black and white image with no greys or colours.
 8-bit colour: 256 colours or greys.
 24-bit colour: 16.7 million colours – the maximum number of colours a

computer can deal with, giving photo-realistic colour.

Compression The 'squashing' of data to reduce file size for storage or to reduce transmission time. Compression can be 'lossy' (such as JPEG) or 'lossless' (such as TIFF LZW). Greater reduction is possible with lossy compression than with lossless.

CPU Central processing unit – the 'brains' of a computer. Carries out all the instructions and calculations needed for the computer to work.

Cropping tool A tool found in image editing software. Allows you to trim an image as you would a real photograph.

D

Data The generic name for any information used by a computer. All data must be in digital form.

Disc or disk Term used to describe any magnetic or optical storage medium.

Dithering A method for simulating many colours or shades of grey with only a few.

dpi Dots per inch. The measurement of a printer's or a video monitor's resolution.

Driver A software utility designed to tell a computer how to operate an external device (i.e. a printer).

F

File A single computer 'document' stored on a disk. Could be a digital photograph or a text-only file. File names allow easy identification of the document.

File format The way that information in a file is stored. In digital photography, common file formats include JPEG, TIFF and GIFF.

173

Filter Photo editing software function that alters the appearance of the image being worked on, much like the physical filters that are fitted to camera lenses.

Flash memory A type of fast memory chip. Remembers all its data even when the power is switched off. Used in digital cameras to prevent losing all the picture if the batteries run out. Also known as SmartMedia.

G

GIF A graphic file format developed by CompuServe for exchange of image files – only supports 8-bit colour.

Grayscale What photographers would call a black-and-white image. Contains a range of grey tones as well and black and white.

H

Hard disk, also known as hard drive. A fast and cheap form of digital storage. Usually refers to a computer's internal disk.

I

Icon A small graphic symbol on a computer screen that can be clicked on with a mouse. It may represent a file, a disk, an application or a command.

Internal storage Digital cameras nearly all have some built-in memory so that images can be stored until they are transferred into a computer. Flash memory (see under F in this glossary) is usually used, and the size (in megabytes – see under M) determines how many images can be stored.

Interpolation Increasing the number of pixels in an image, or filling in missing colour information by averaging the values of neighbouring pixels. This 'upsampling' cannot add detail or information, but it is used by most digital cameras when recording images.

J

Jaggies The jagged, stepped effect seen in images whose resolutions are so low that individual pixels are visible.

JPEG A file compression standard established by the Joint Photographic Experts Group. Capable of a very high level of compression, but it is a 'lossy method' and can degrade image quality somewhat. See also Compression, under C.

L

LCD monitor A small colour screen found on many digital cameras . Allows previewing and reviewing of images as they are taken in order to check composition, focus and lighting.

M

Marquee Outline of dots created by image editing software to show area selected for manipulation, masking or cropping.

Modem Device that allows computers to communicate over telephone lines.

Morphing A special effect common in films when one image smoothly changes into another. Now available to home users in such software as Power Goo.

N

Network Two or more computers and peripherals that are connected by cable links or over telephone lines using modems. The Internet is the world's largest network.

Noise Unwanted electrical interference that degrades electrical equipment. In digital cameras, this occurs most often in very low lighting or in shadow areas. Takes the form of pixels of the wrong colour appearing at random in dark areas.

O

Optical viewfinder A viewfinder system that shows a similar view to that seen by the camera lens. Typical of 35mm compact cameras. Useful because it uses no power, but it can cause parallax (see under P in this glossary) and focusing errors.

P

Parallax error Mis-framing of a photograph caused by the different viewpoints of a camera lens and an optical viewfinder. Especially in close-ups.

PC Personal computer.

PC card also known as PCMCA card A popular standard for removable cards that is used both in some digital cameras and in laptop computers. PC cards can contain hard disks, modems or flash memory (see under F). They are being replaced by smaller and cheaper smart media.

Pentium II Latest generation of microprocessor.

Peripheral Any item that connects to a computer (ie printer, scanner, camera).

Pixel (PlCture Element) The smallest element of a digitized image. Also, one of the tiny points of light that make up a picture on a computer screen.

R

RAM Random access memory. The computer memory where the CPU (see under C) stores software and other data currently being used. A large amount of RA usually assists speed of image manipulation.

Resize Changing the resolution or physical size of an image.

Resolution Measure of the amount of information in an image expressed in terms of the number of pixels (see under P) in a unit of length (ie pixels per millimetre or pixels per inch). Camera resolution is usually defined as the actual number of pixels in the image produced (see 640 X 480). See also dpi.

RGB Red, green and blue. TV, computer monitors and digital cameras use a mixture of R, G and B to represent all the colours in an image.

RCM Read only memory. A fixed memory that can be read, but not written. Inside a computer it contains the basic code that allows the CPU to work.

S

Serial link The most common method of connecting a digital camera to a computer for image transfer.

T

Thumbnail A small, low-resolution version of a larger image file that is used for quick identification and for displaying many images on a single screen.

TIFF The standard file format (see under F) for high-resolution bitmapped (see under B) graphics.

TWAIN Protocol for exchanging information between applications and devices such as digital cameras.

U

Unsharp masking A software feature that selectively sharpens a digital image in areas of high contrast while having little effect on areas of solid colour. The effect is to increase apparent detail and sharpness.

175

ACKNOWLEDGEMENTS

THANKS TO...
Stewart Greenfield for his help with the original concept.
To Stephen Mold, Jenny Cartwright and Chris Luce and others at MGI for their
technical advice and helpful collaboration.

CONTRIBUTORS – WORDS
Simon Joinson: text throughout the book, also planning the contents,
and technical advice.
Matthew Williams: introductory features in Section 1.
Steve Davey: Section 2.
Peter Cope: starter projects in Section 3.

CONTRIBUTORS – IMAGES AND IMAGING
Simon Joinson and What Digital Camera?
– images in Section 1.
Stewart Greenfield, Greenfield Computer Marketing
– eqipment photos in Section 1
Steve Davey/La Belle Aurore – images in Section 2.
Peter Cope – starter projects images in Section 3.
Mel Petersen – other projects in section 3.

Special thanks to the equipment manufacturers for providing images for Section 1

In-house credits

EDITORIAL DIRECTOR
Andrew Duncan
ART DIRECTOR
Mel Petersen
DESIGNER
Beverley Stewart
ASSISTANT EDITOR
Nicola Davies
SUB-EDITOR
Sarah Barlow